Nasher Sculpture Center Handbook

Nasher Sculpture Center Handbook

Edited by Steven A. Nash
with essays by Steven A. Nash
and Mark Thistlethwaite

Published in conjunction with the opening of the Nasher Sculpture Center in
Dallas, Texas, in October 2003.

Copyright © 2003 Nasher Sculpture Center

Copyright © all photographic material see pg. 191

ISBN 0-9741221-2-2

Designed by 2x4, Alex Lin and Georgianna Stout

Printed and bound in Germany by Cantz

The garden accommodates approximately 30 pieces of sculpture

Stone
Travertine quarried in southern Tuscany:
Exterior walls clad in 2,522 pieces of Etrusco Travertine with water jet finish, each 2′ x 4′, 190 lbs.
Interiors clad in 2,470 pieces of Classic Novona Travertine with honed finish, each 2′ x 4′ and 190 lbs.
Garden walls contain 2,999 pieces of Etrusco Travertine with water jet finish, each 2′ x 4′, 190 lbs.
Verde Fontaine (green granite) quarried in South Africa:
Garden paths constructed from 10,835 Verde Fontaine cobbles with water-jet finish
Terraces covered in 1,439 Verde Fontaine pavers

Trees
The garden contains Live Oak, Cedar Elm, Afghan Pine, Crepe Myrtle, Weeping Willow, and Bamboo

Six Burr Oaks on the front facade
52 Magnolias on the perimeter

Lifts
Truck: platform 15′ x 32′, clearance 13′-6 1/2″, capacity 60,000 lbs., speed 50 fpm
Freight: platform 8′-11″ x 15′-9″, door 8′-0″w x 9′-0″h, capacity 20,000 lbs., speed 117 fpm
Passenger: platform 6′-9 3/4″ x 5′-5 1/2″, door 3′-6″w x 7′-0″h, capacity 3,500 lbs., speed 150 fpm
Dumbwaiter: platform 30″w x 30″d x 48″h, door 3′-6″w x 4′-0″h, capacity 500 lbs.

Project Data

Location
2001 Flora St.
Dallas, Texas USA

Client
Nasher Foundation, Dallas

Funding
Raymond D. Nasher

Project Design
2000

Execution
2001-2003

Gross Surface
2.4 acres (104,544 ft²)

Building
55,000 ft²

Garden
1.42 acres (61,952 ft²)

Indoor Exhibition Space
10,000 ft²

Project Cost
$70 million

Construction Cost
$45 million

Architects

Renzo Piano Building Workshop,
Genoa/Paris

Project Team
R. Piano, M. Baglietto, and B. Terpeluk

General Contractor
Beck, Dallas

Associate Architects
Beck Architecture, Dallas
Interloop A/D, Houston

Landscape Architect
Peter Walker and Partners, Berkeley

Design S.M.E.P. Engineers
Ove Arup & Partners International,
London

Civil Engineer
Halff Associates, Dallas

Associate Structural Engineer
Datum Engineers, Dallas

Associate M.E.P. Engineer
Arjo Engineers, Dallas

Project Details

Roof and Structural
248 extra-white glass panels (228 shaded, 20 unshaded), each 4' x 16', 1,200 lbs.
60 opaque steel panels, each 4' x 16', 1,200 lbs.
Roof height is 16' at the wall, 17' at the center point
Glass systems by Sunglass (Padua, Italy)
912 sunshade pieces, each 4' x 4', 150 lbs.
Sunshade apertures face due north to block all direct sunlight
Aluminum sunscreens by La Societa Sider s.r.l. (Bologna, Italy)
Roof system consists of 161 steel roof beams supported by 322 steel tension rods
Structural steel by Gipponi s.r.l. (Bergamo, Italy)
Main staircase: three stairs, each 5,000 lbs. and landing, 20,000 lbs., fabricated from cold rolled steel

Galleries and Interior Amenities
Full 8" wide oak plank flooring
Indoor galleries: two ground level gallery bays, entry bay, and lower level gallery, accommodate approximately 80 pieces of sculpture
Café, with indoor/outdoor seating and private dining, is approximately 2,000 ft²
Museum store is 750 ft²
Indoor/outdoor auditorium, with 12' x 32' retractable wall, seats approximately 225 indoors and 150 outdoors

Garden and Terraces
7,680 ft² of terrace, 2/3 covered
Garden and Flora Street terraces linking indoor and outdoor exhibition spaces accommodate approximately 8-12 pieces of sculpture
Terraced Garden contains 16 grassed terraces
The soil mixture in the garden is a three-layer, sports field technology system designed to support heavy sculpture without foundations and to quickly drain heavy rain

Plate 55

James Turrell (American, born 1943)
Tending, (Blue), 2003
Rendering by Interloop A/D, Houston
Black granite, limestone, and plaster
exterior: 312 x 312 x 312 in. (792.5 x 792.5 x 792.5 cm.);
interior: 264 x 264 x 264 in. (670.6 x 670.6 x 670.6 cm.)

"It is fascinating to work with an artist who basically understands nature and is creating one of the wonders of the world in the Roden Crater. I thought that to bring to our Sculpture Center a sky space developed specifically for the situation would be truly remarkable. I wanted it to be a magnet at the end of the garden." – R.N.

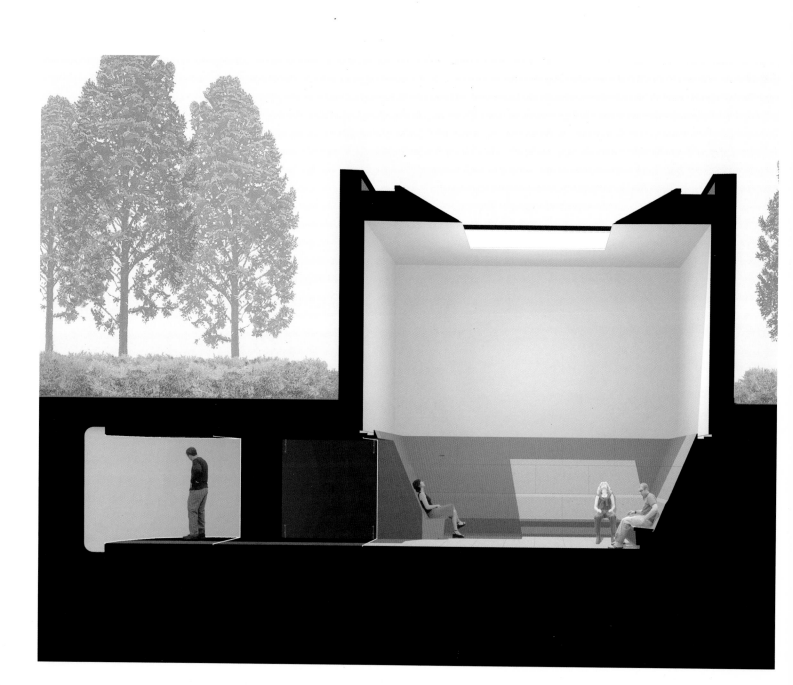

Plate 54

188 / 189 Catalogue

Carl Andre (American, born 1935)
Al Rectagrate, 2002
Forty-four aluminum ingots, 5 x 240 x 18 in.
(12.7 x 609.6 x 45.7 cm.) overall

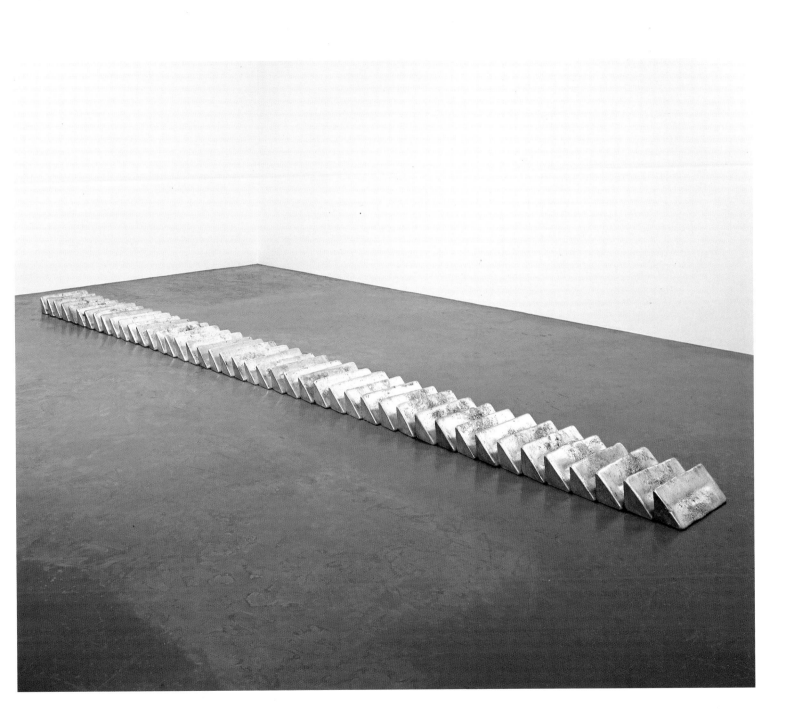

Plate 53

Mark di Suvero (American, born China, 1933)
Eviva Amore, 2001
Steel, 424 x 564 x 360 in. (1077 x 1432.6 x 914.4 cm.)

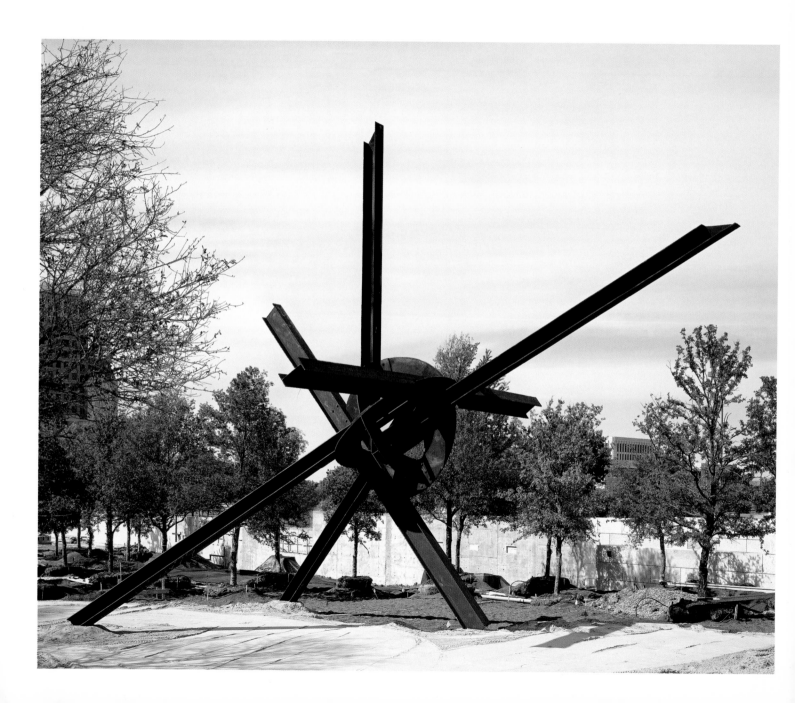

Plate 52

Antony Gormley (British, born 1950)
Quantum Cloud XX (*tornado*), 2000
Stainless steel bar, 91 3/4 x 58 5/8 x 47 1/4 in.
(233 x 148.9 x 120 cm.)

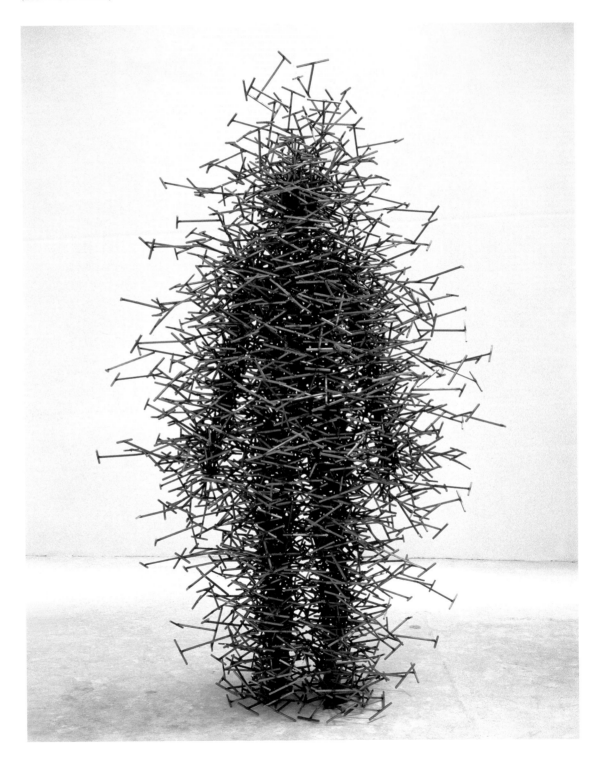

Plate 51

Joel Shapiro (American, born 1941)
Untitled, 1996–99
Bronze, 288 x 171 x 137 1/2 in.
(731.5 x 434.3 x 349.3 cm.)

"I first saw this work on the roof of the Metropolitan Museum in New York, and it was not only the star of that particular installation, but also truly one of Shapiro's best pieces. It is dynamic and the relation of the forms changes. It struck me immediately that it would be fabulous in the garden and totally different from the roof of the Met." – R.N.

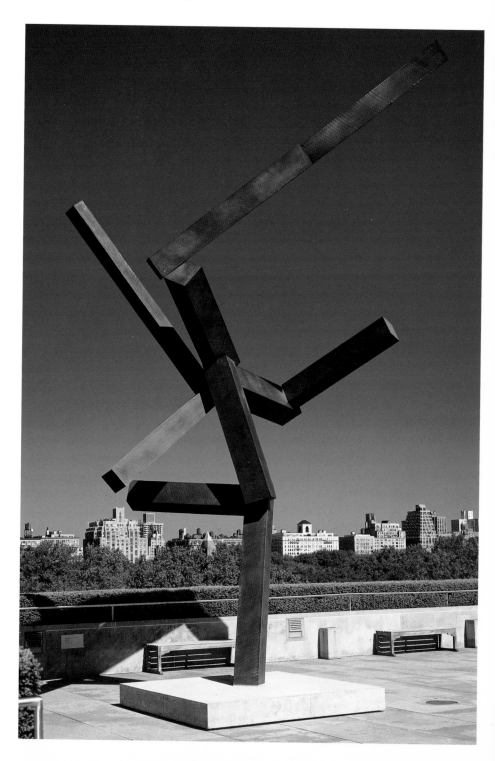

Plate 50

184 / 185 Catalogue

Richard Long (British, born 1945)
Midsummer Circles, 1993
Delabole slate, 208 in. (528.3 cm.) in diameter

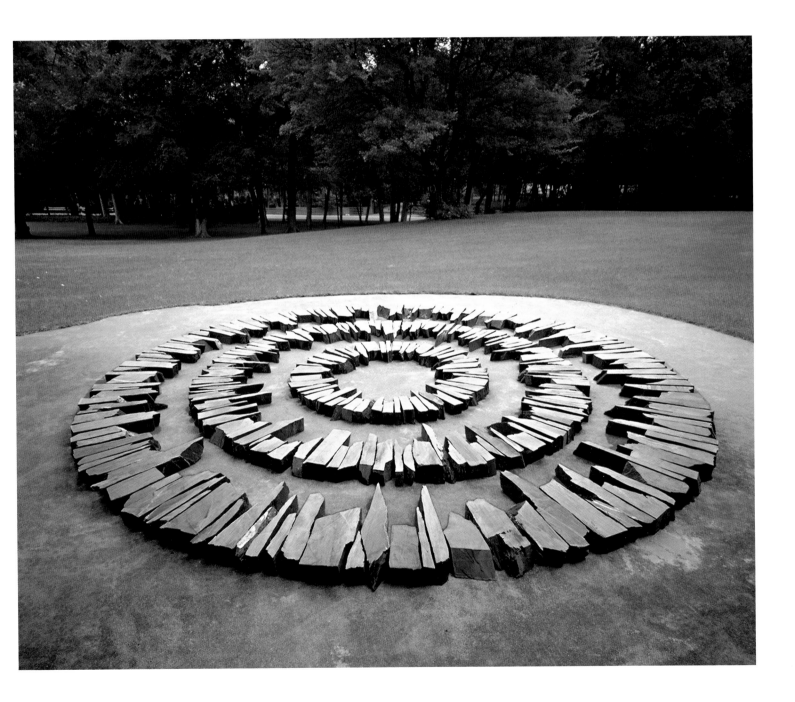

Plate 49

Magdalena Abakanowicz (Polish, born 1930)
Bronze Crowd, 1990–91
Bronze, Thirty-six pieces, each approximately
71 1/8 x 23 x 15 1/2 in. (180.7 x 58.4 x 39.4 cm.)

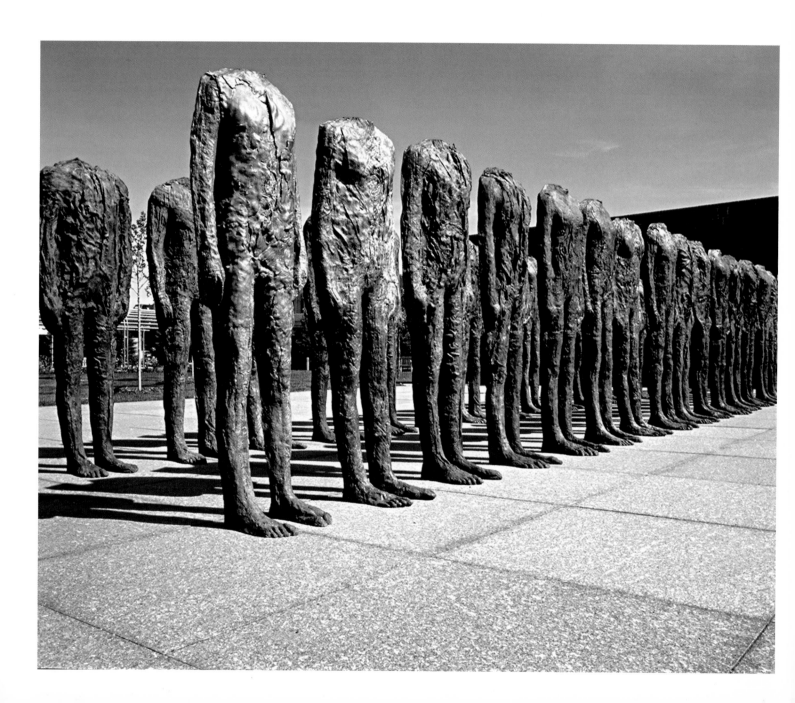

Plate 48

Tony Cragg (British, born 1949)
Glass Instruments, 1987
Eroded glass, wood, and metal
82 5/8 x 66 7/8 x 55 1/8 in.
(209.9 x 169.9 x 140 cm.)

"Cragg has worked with all kinds of materials. Here, he has found the steel and wooden elements to create a platform that looks old, battered, and bruised, and then placed these glass forms, which he's taken out of another context and altered by sand blasting and putting holes in them, on the surface. I particularly like this work because it has both simplicity and great complexity." – R.N.

Ellsworth Kelly (American, born 1923)
Untitled, 1986
Bronze, 119 7/8 x 17 5/16 x 1 1/4 in.
(304.5 x 44 x 3.2 cm.)

Plate 46

180 / 181 Catalogue

Jeff Koons (American, born 1955)
Louis XIV, 1986
Stainless steel, 46 x 27 x 15 in. (116.8 x 68.6 x 38.1 cm.)

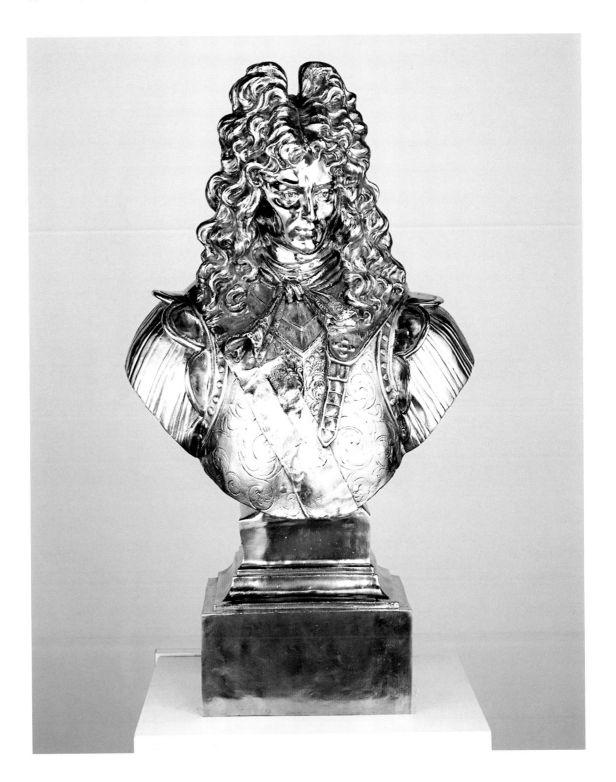

Plate 45

Jonathan Borofsky (American, born 1942)
Hammering Man, 1984–85
Painted steel plate and Cor-Ten steel
240 x 108 x 18 1/2 in.
(609.6 x 274.3 x 47 cm.)

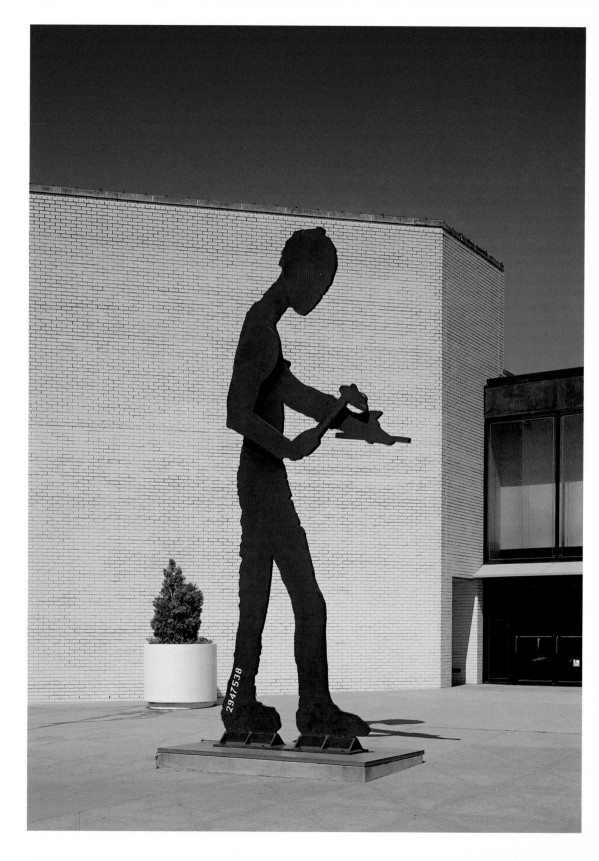

Plate 44

178/179 Catalogue

Martin Puryear (American, born 1941)
Night and Day, 1984
Painted wood and wire, 83 1/2 x 118 1/2 x 5 in.
(212.1 x 301 x 12.7 cm.)

"My wife and I had the good fortune of being asked to be judges at the sculpture competition at the
Guggenheim Museum in New York about 20 or 25 years ago. There were about half a dozen
works by different sculptors and we selected Puryear. Then later we saw *Night and Day* and imme-
diately knew that it was one of the most important works. It makes such a statement formally
and sociologically." – R.N.

Plate 43

George Segal (American, 1924–2000)
Rush Hour, 1983 (cast 1985–86)
Bronze, 73 x 74 x 67 in.
(185.4 x 188 x 170.2 cm.)

"I think it is a fascinating sculpture – the American version of Rodin's *Burghers of Calais*. The models for the Segal were all friends of his. It is an important symbol of American lifestyle, and was one of the first works for which Segal used this kind of dark blue-black patina." – R.N.

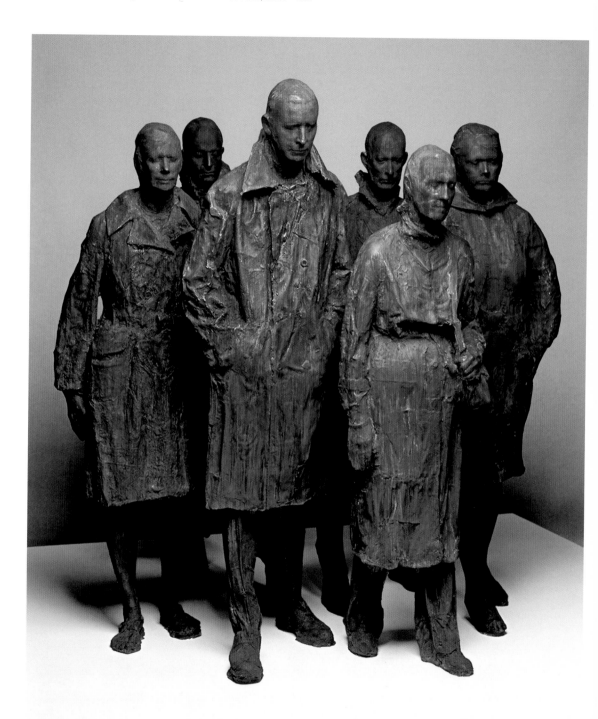

Plate 42

176/177 Catalogue

Alain Kirili (French, born 1946)
Commandment V. 1980
Forged iron, Seventeen pieces
Tallest piece: 12 1/2 x 6 x 7 in. (31.8 x 15.2 x 17.8 cm.)

Plate 41

Roy Lichtenstein (American, 1923–1997)
Double Glass, 1979
Painted and patinated bronze, 56 x 42 x 17 in.
(142.2 x 106.7 x 43.2 cm.)

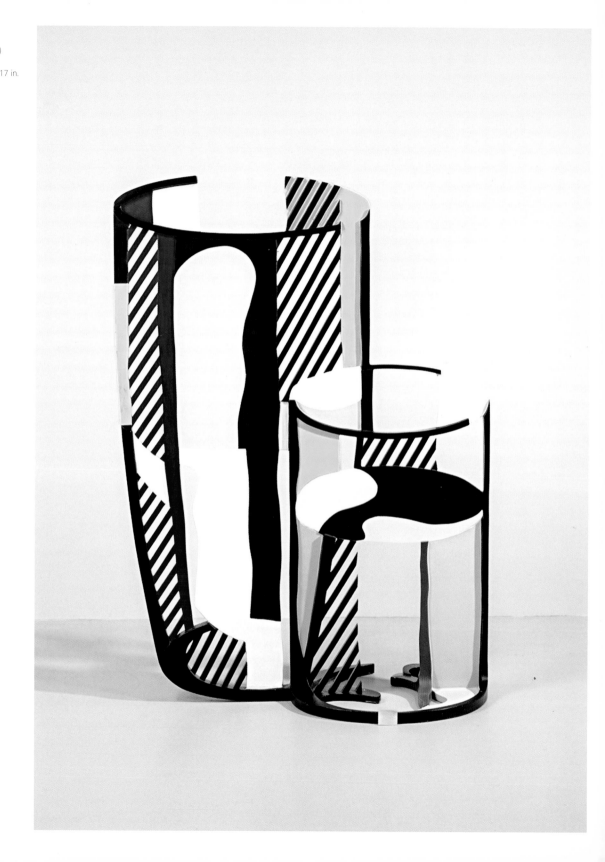

Plate 40

174 / 175 Catalogue

Donald Judd (American. 1928–1994)
Untitled, 1976
Aluminum and anodized aluminum, 8 1/4 x 161 x 8 in. (21 x 408.9 x 20.3 cm.)

Plate 39

Claes Oldenburg (American, born Sweden, 1929)
Typewriter Eraser, 1976
Ferro cement, stainless steel, and aluminum
on steel base, 89 x 90 x 63 in.
(226.1 x 228.6 x 160 cm.)

"Oldenburg deals with objects that are very common. *The Eraser* is made out of concrete, painted aluminum, and stainless steel. Most younger people who see this work today have no idea what it represents, because they have never seen a typewriter eraser. It has become an historical artifact." – R.N.

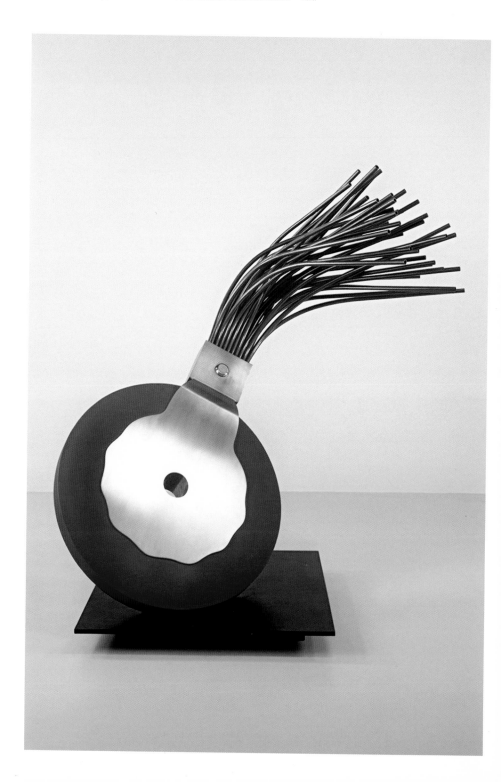

Plate 38

172 / 173 Catalogue

John Chamberlain (American, born 1927)
Williamson Turn, 1974
Painted and chromium-plated steel, 46 x 37 x 48 in. (116.8 x 94 x 121.9 cm.)

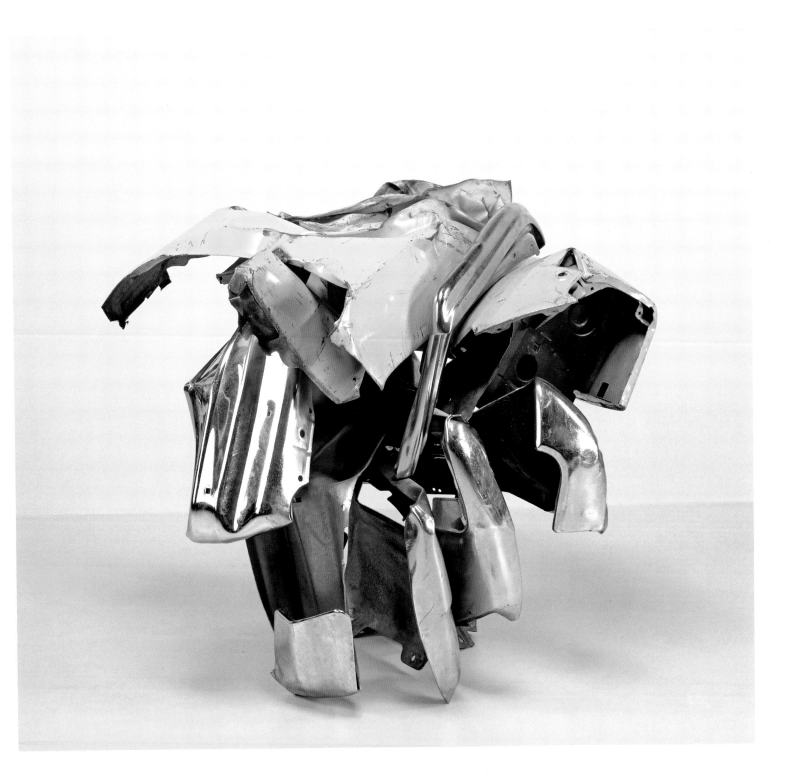

Plate 37

Willem de Kooning
(American, born The Netherlands, 1904–1997)
Clamdigger, 1972
Plaster, 59 1/2 x 29 5/8 x 23 3/4 in.
(151.1 x 75.2 x 60.3 cm.)

"I saw this sculpture at the Mitchell-Innes and Nash Gallery in New York and thought I'd never seen a patina like this in plaster form. I'd seen the bronze *Clamdigger*, of course, but not the plaster – I'd never known about the plaster. It looks like it has oil and wax and paint all mixed together with the plaster. De Kooning's daughter told me she thought that in some sense it may have been a self portrait." – R.N.

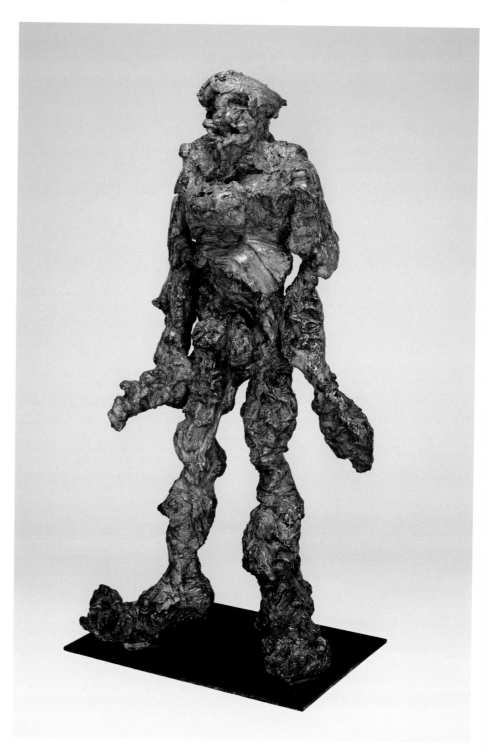

Plate 36

170/171 Catalogue

Richard Serra (American, born 1939)
My Curves Are Not Mad, 1987
Cor-Ten steel, 168 x 539 3/8 x 139 in. (426.7 x 1370 x 353.1 cm.)

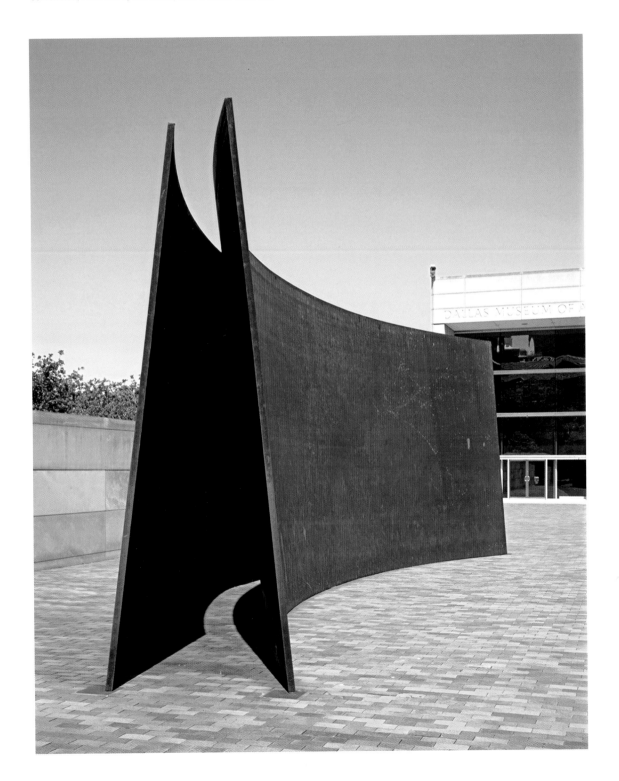

Plate 35

Richard Serra (American, born 1939)
Inverted House of Cards, 1969–70
Cor-Ten steel, 55 1/4 x 101 3/4 x 101 1/2 in.
(140.3 x 258.4 x 257.8 cm.)

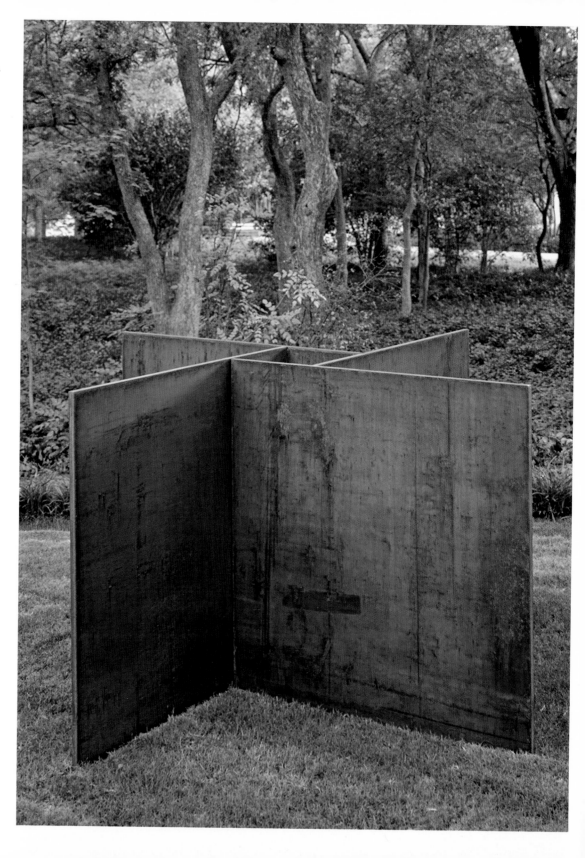

Plate 34

Jean Dubuffet (French, 1901–1985)
The Gossiper II (*Le Deviseur II*), 1969–70
(enlargement 1984)
Painted polyester resin, 120 x 81 3/4 x 85 1/4 in.
(304.8 x 207.6 x 216.5 cm.)

"*The Gossiper* is essentially a self-portrait of the artist. He is looking out at the world, laughing and talking and commenting on all the crazy things around him. Dubuffet died the year we saw this piece, and months later his estate finally agreed to sell it to us."

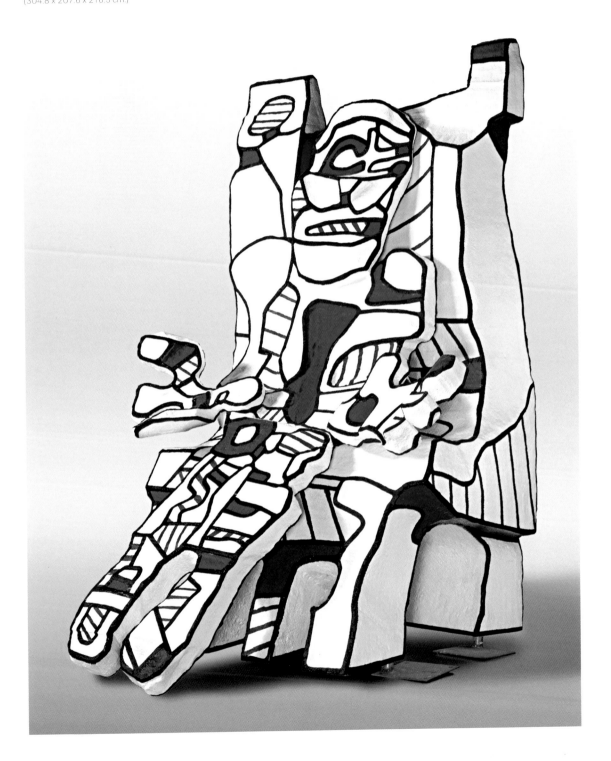

Plate 33

Henry Moore (British, 1898–1986)
Reclining Figure: Angles, 1979 (cast 1980)
Bronze, 48 1/4 x 90 1/4 x 61 3/4 in. (122.6 x 229.2 x 156.8 cm.)

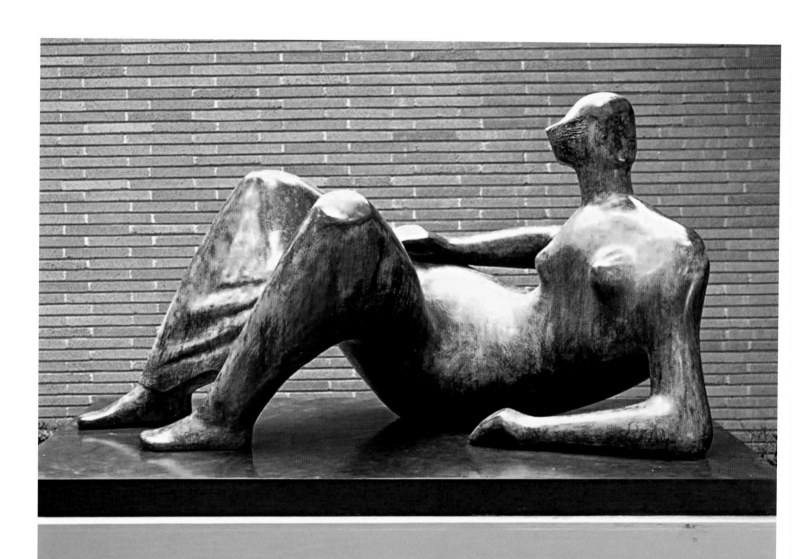

Plate 32

Henry Moore (British, 1898–1986)
Working Model for Three-Piece No. 3:
Vertebrae, 1968
Polished bronze, 41 1/8 x 93 x 48 in.
(104.5 x 236.2 x 121.9 cm.)

"We visited Henry Moore at his studio and home in Much Hadham, outside of London, in 1967. He had three small stones he was putting together in the form of a new sculpture, which turned out to be *Vertebrae*. In his mind, it was truly the vertebrae of a human being. You notice you have three different pieces that fit into each other as if it were the backbone of a reclining body." – R.N.

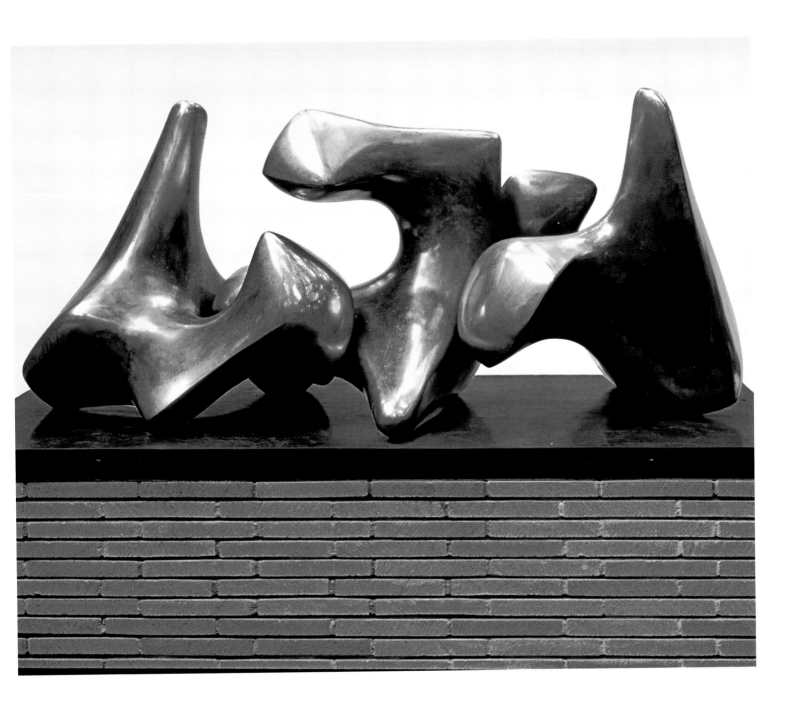

Plate 31

Barnett Newman (American, 1905–1970)
Here III, 1965–66
Stainless and Cor-Ten steel
125 7/8 x 23 1/2 x 18 5/8 in. (319.7 x 59.7 x 47.3 cm.)

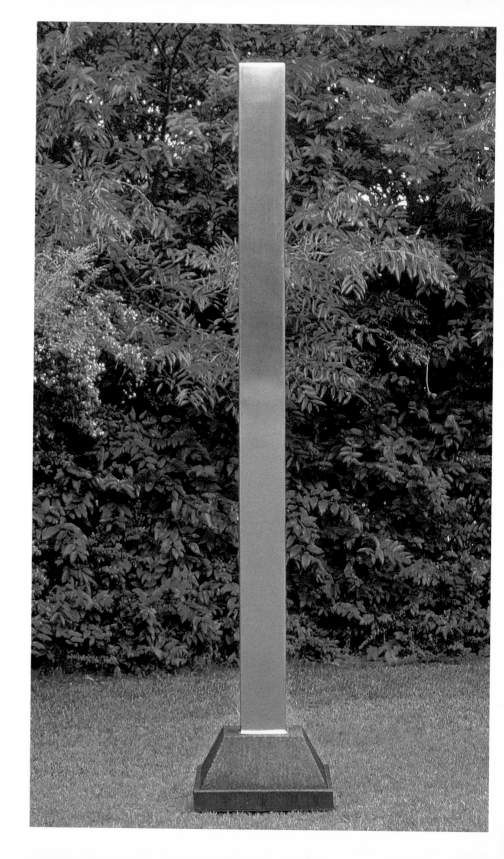

Plate 30

164 / 165 Catalogue

Barbara Hepworth (British, 1903–1975)
Squares with Two Circles (*Monolith*)
1963 (cast 1964)
Bronze, 124 x 65 x 30 in.
(315 x 165.1 x 76.2 cm.)

"We saw this work in front of the Tate Gallery in London, where it was a part of a Hepworth exhibition. In some ways it is like two different works. The composition changes from one side to the other. There are convex elements on one side and concave on the other, and the patina also varies. Hepworth had been lending the piece to Oxford University. She was willing to sell it but had to send a different work to Oxford on loan." – R.N.

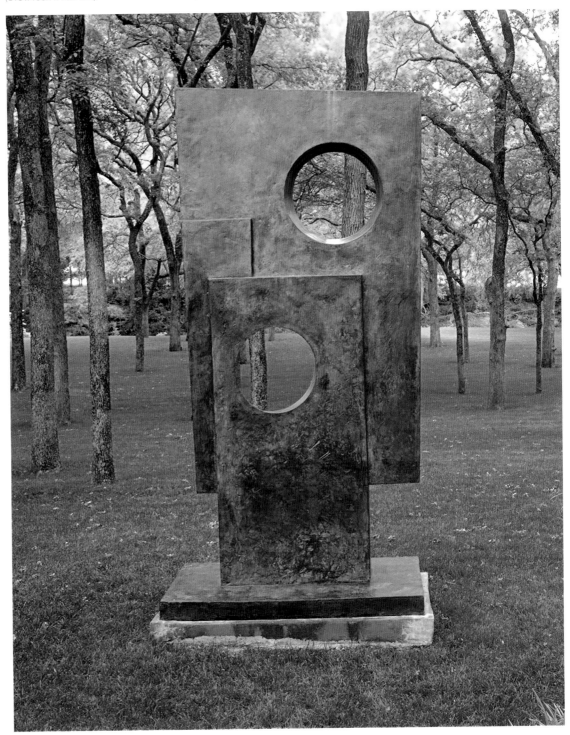

Plate 29

Tony Smith (American, 1912–1980)
The Snake is Out, 1962 (fabricated 1981)
Painted steel, 180 x 278 x 226 in. (457.2 x 706.1 x 574 cm.)

"When our collection was shown in Florence in 1988, *The Snake is Out* was too big to move down the narrow streets leading to the Forte di Belvedere, the site of the show. So I went to our ambassador in Rome and he helped line up two Army helicopters so the work could be flown in two pieces to the site. I have a movie of it flying over Florence, dangling in space." – R.N.

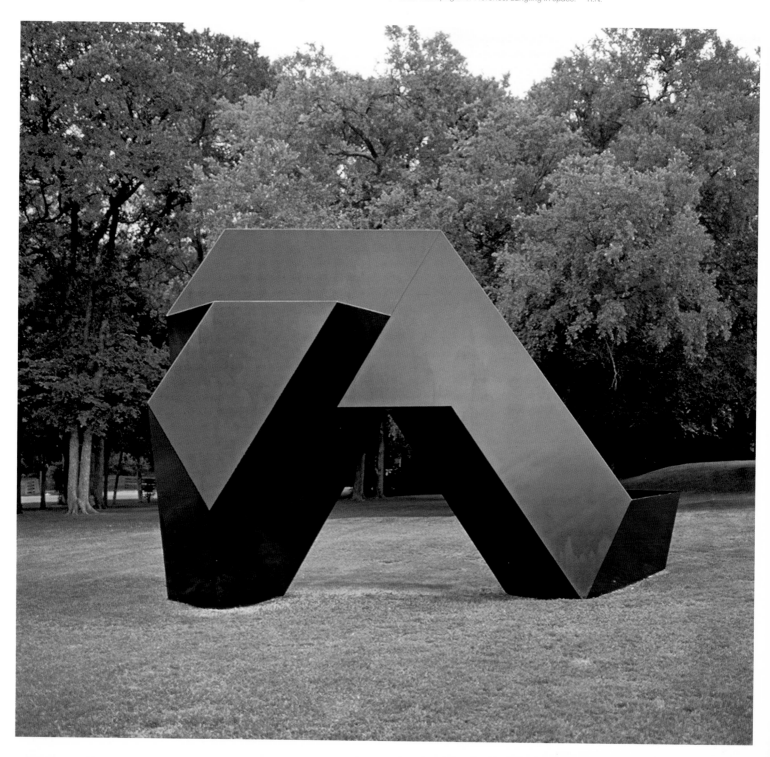

Plate 28

Anthony Caro (British, born 1924)
Sculpture Three, 1961
Painted steel, 118 x 174 1/2 x 51 in. (299.7 x 443.2 x 129.5 cm.)

Plate 27

Jean Arp (French, 1886–1966)
Torso with Buds (*Nu aux bourgeons*), 1961
Bronze, 73 7/8 x 15 1/2 x 15 in.
(187.6 x 39.4 x 38.1 cm.)

"This was a very important piece for my wife and me, with great symbolic meaning. We had been collecting works of American art and pre-Columbian and Oceanic art, and suddenly my wife saw this Arp at the Sidney Janis Gallery in New York. She decided to give it to me as a birthday present. It was the first major work of modern sculpture we acquired. It is one of the great Arps – both a human figure and a flower figure – a combination of both." – R.N.

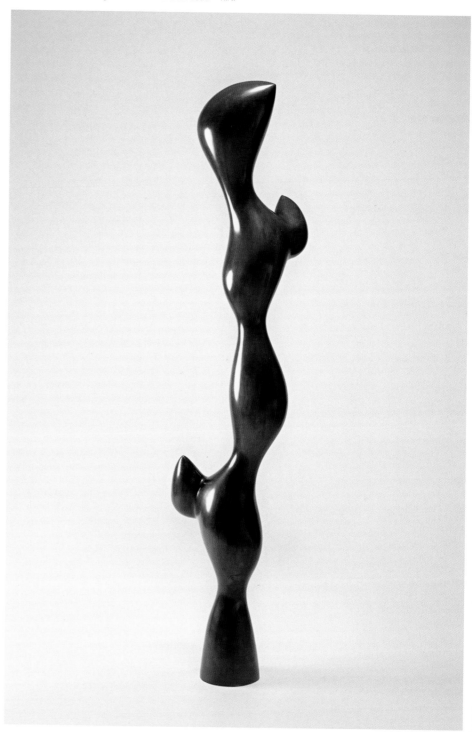

Plate 26

David Smith (American, 1906–1965)
Voltri VI, 1962
Steel, 98 7/8 x 102 1/4 x 24 in.
(251.1 x 259.7 x 61 cm.)

"Gian Carlo Menotti was organizing the Festival of Two Worlds in Spoleto in Italy in 1962, and he asked his friend David Smith to make a sculpture to go into the square in Spoleto. He arranged for Smith to work in an old steel factory in Voltri near Genoa. In one month Smith created 27 great sculptures including four wagon pieces. They are outstanding examples of how he incorporated found objects of all kinds into his powerful works. This one used to belong to Nelson Rockefeller." – R.N.

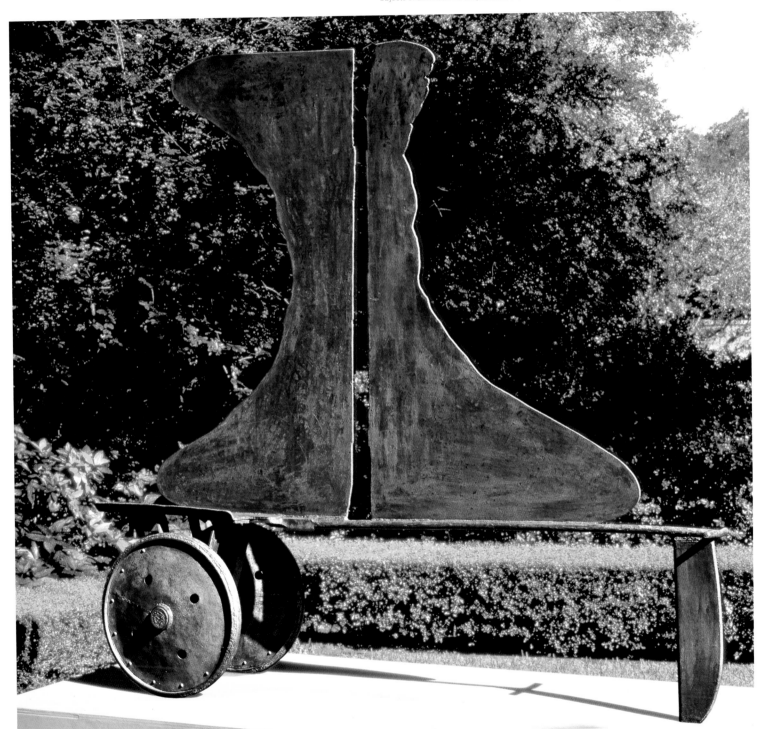

Plate 25

David Smith (American, 1906–1965)
Tower Eight, 1957
Silver, 46 1/2 x 13 x 10 5/8 in.
(118.1 x 33 x 27 cm.)

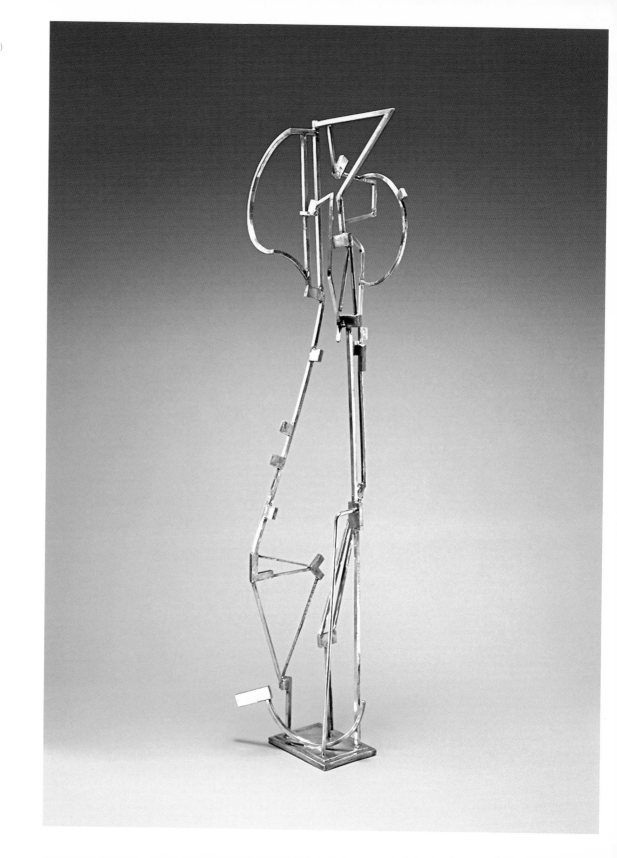

Plate 24

David Smith, (American, 1906–1965)
House in a Landscape (*Rural Landscape with Manless House*), 1945
Steel, 18 1/2 x 24 3/4 x 6 in. (47 x 62.9 x 15.2 cm.)

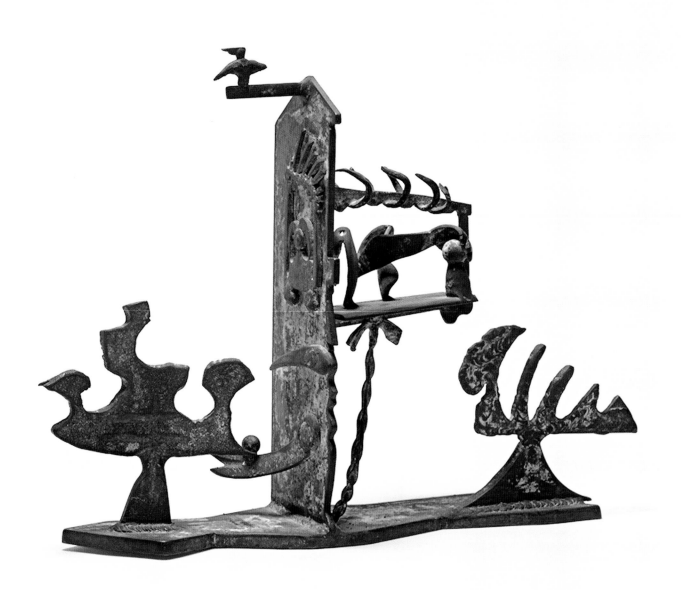

Plate 23

Joan Miró (Spanish, 1893–1983)
Caress of a Bird (*La Caresse d'un oiseau*), 1967
Painted bronze, 123 x 43 1/2 x 19 in.
(312.4 x 110.5 x 48.3 cm.)

"This is a particularly whimsical and humorous sculpture, and you can't help smiling when you see it. It also shows the way the artist thought and worked. It is put together from all kinds of different objects: the green body of the figure is an ironing board, the head is a straw hat, and the stomach is a tortoise shell. On the back are two bocce balls. Miró was inspired by found objects and used them freely in his work." – R.N.

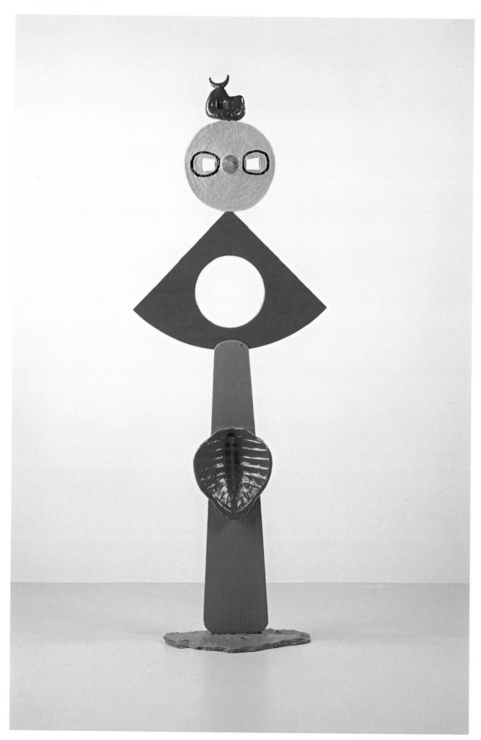

Plate 22

Joan Miró (Spanish, 1893–1983)
Moonbird (*Oiseau lunaire*), 1944–46 (enlargement 1966, cast 1967)
Bronze, 90 x 80 1/2 x 57 3/4 in. (228.6 x 204.5 x 146.7 cm.)

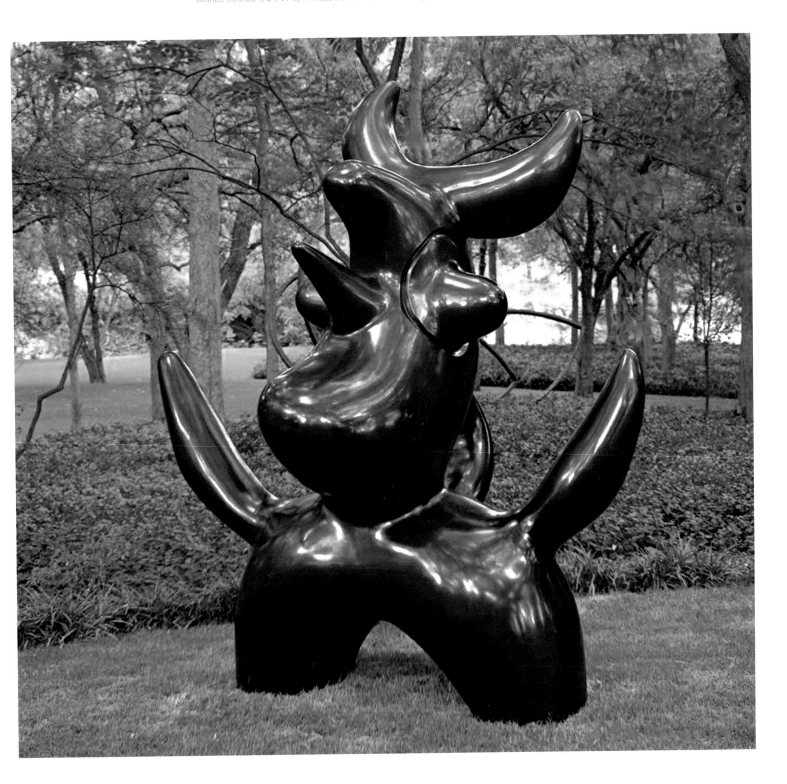

Plate 21

Max Ernst (French, born Germany, 1891–1976)
The King Playing with the Queen, 1944 (cast 1954)
Bronze, 37 7/8 x 33 x 21 1/8 in. (96.2 x 83.8 x 53.7 cm.)

"When the exhibition of our collection was at the Centro Reina Sofia in Madrid in 1988, the show was opened by Queen Sofia. Patsy and I took her through the whole exhibition and she was particularly fascinated with the Ernst and its title, *The King Playing with the Queen*. You have the King with large horns moving the figure of the Queen on a game board, but he is also holding another figure behind his back, so he can't lose." – R.N.

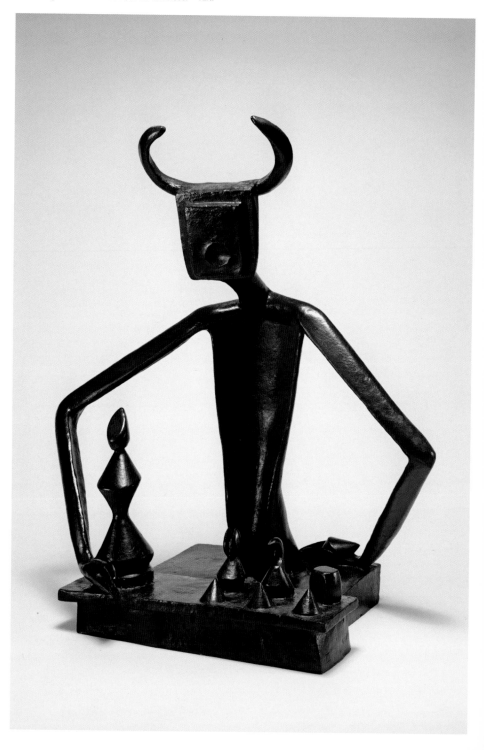

Plate 20

Alexander Calder (American, 1898–1976)
Three Bollards (*Trois Bollards*), 1970
Painted steel, 137 x 114 x 137 in.
(348 x 289.6 x 348 cm.)

"We first saw the large, black, painted sculpture *Trois Bollards* in a Calder exhibition in Milan. In the same show was a star-shaped stabile painted red, white, and black. My wife liked the colored piece and I liked the black one. Later we learned that both pieces had been sent to Paris to the Maeght Gallery. We flew to Paris and went to the gallery, but, upon entering, first spotted Miró's *Moonbird*, which we had always loved and decided on the spot to buy. In the end, we also were able to negotiate the purchase of *Trois Bollards*, so it was quite a day." – R.N.

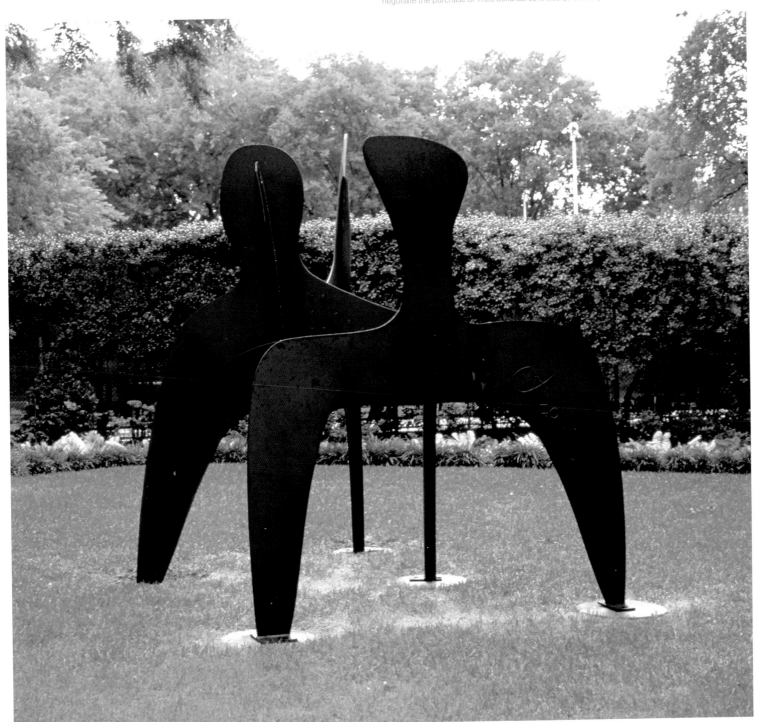

Plate 19

Alexander Calder (American, 1898–1976)
The Spider, 1940
Painted sheet metal and steel rod
95 x 99 x 73 in. (241.3 x 251.5 x 185.4 cm.)

"One of the most exciting sculptures we have is Calder's *Spider*. He did it in 1940, when he'd done some stabiles and some mobiles, and now was working with the new form of the stabile mobile. The placement of the various forms is vital to the balance of the entire piece. In this work, he created movement and stability simultaneously." – R.N.

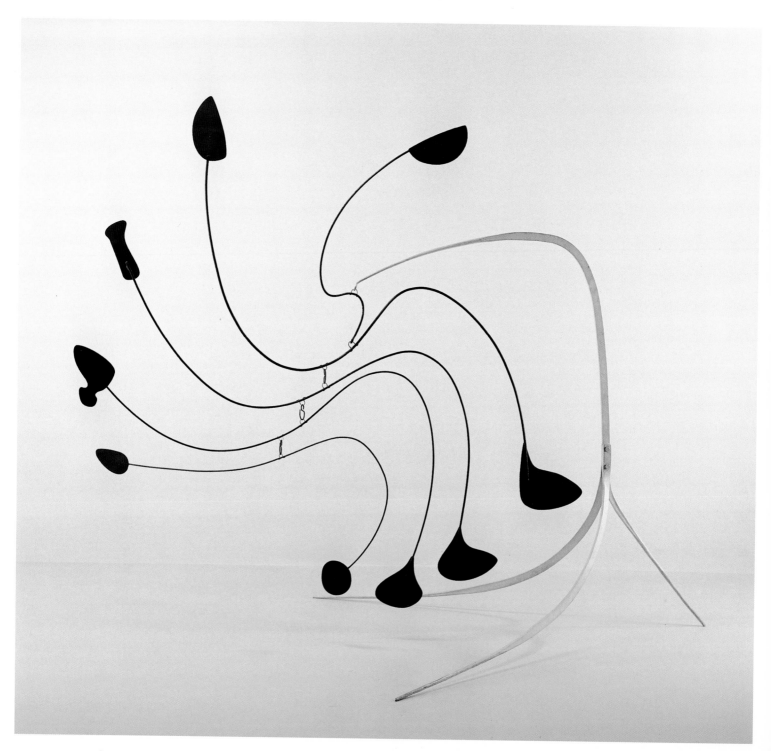

Plate 18

Julio Gonzalez (Spanish, 1876–1942)
Woman with a Mirror (*Femme au miroir*)
ca. 1936–37 (cast ca. 1980)
Bronze, 80 15/16 x 26 3/8 x 14 3/16 in.
(205.6 x 67 x 36 cm.)

"González was one of the first artists to use found objects and assemble them together into figures.
He actually taught Picasso how to weld and was a huge influence not only on Picasso but
also a later generation of artists including David Smith. This work came from the collection of
González's daughter." –R.N.

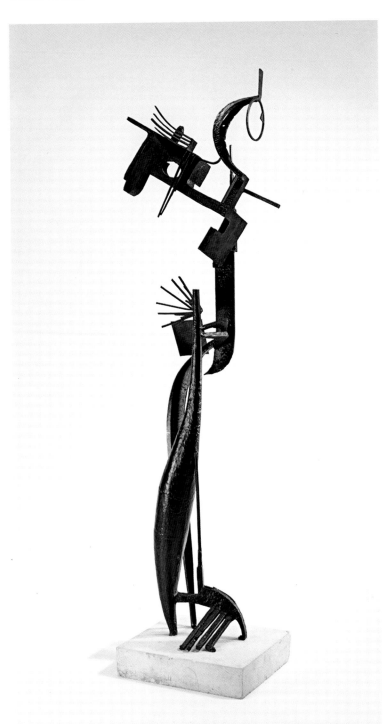

Plate 17

Alberto Giacometti (Swiss, 1901–1966)
Diego in a Cloak (*Diego au manteau*), 1954
Painted bronze, 15 1/8 x 13 1/2 x 8 3/4 in.
(38.4 x 34.3 x 22.2 cm.)

"We own three painted bronze busts of Diego Giacometti by his brother Alberto, which we bought
from the Maeght Foundation out of an exhibition in Monterrey, Mexico. Later we got to know
Diego well and bought a number of pieces of the bronze furniture he made." – R. N.

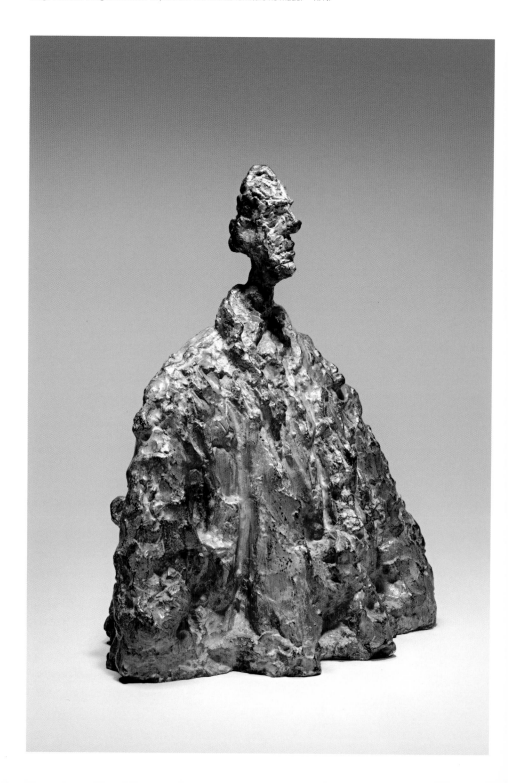

Plate 16

Alberto Giacometti (Swiss, 1901–1966)
Spoon Woman (Femme cuillère)
1926 (cast 1954)
Bronze, 56 3/4 x 20 X 9 in.
(144.1 x 50.8 x 22.9 cm.)

"We actually have an African spoon figure like the one that inspired Giacometti in this work.
It is a large, majestic piece with rather strange proportions. Emphasis is on the stomach and the
whole idea of fecundity, birth, and the creative forces of a woman." – R.N.

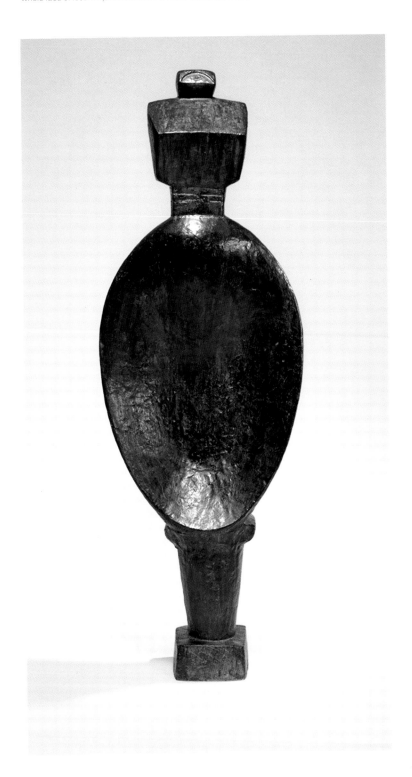

Plate 15

Naum Gabo (American, born Russia, 1890–1977)
Constructed Head No. 2, 1916 (enlargement, 1975)
Stainless steel, 70 x 54 1/4 x 48 in.
(177.8 x 137.8 x 121.9 cm.)

"The way that this piece really seems to look at you, even from a distance, is amazing. Gabo began the idea with a cardboard piece just before the start of the Russian Revolution. Much later when he came to this country, he was able to realize a number of works designed earlier. He took stainless steel and bent it and welded pieces together to create this great head." – R.N.

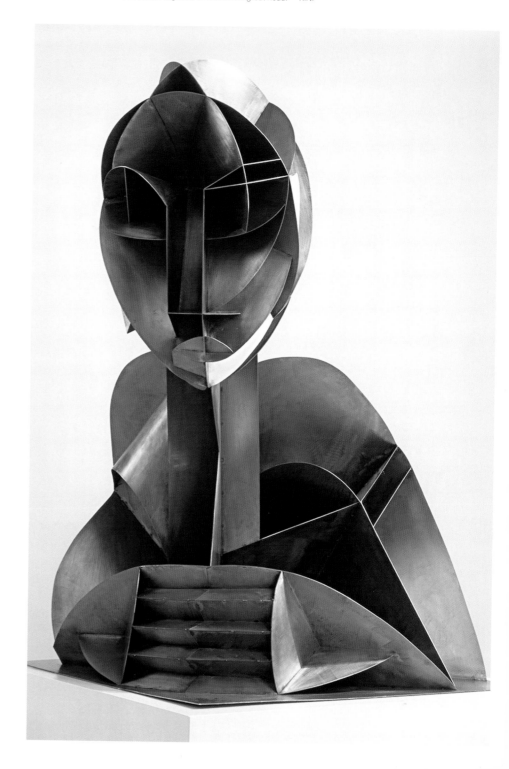

Plate 14

Jacques Lipchitz (American, born Lithuania, 1891–1973)
Seated Woman (*Cubist Figure*), 1916
Stone, 42 1/2 x 11 1/4 x 12 1/4 in.
(108 x 28.6 x 31.1 cm.)

"This was 1916, and a major breakthrough that embodied Cubism in its ultimate form. Lipchitz has changed the figure into different curved and angular elements, and has integrated all the different views, the side, the back. The eye rearing out of the face is a major focus; it really makes the piece." – R.N.

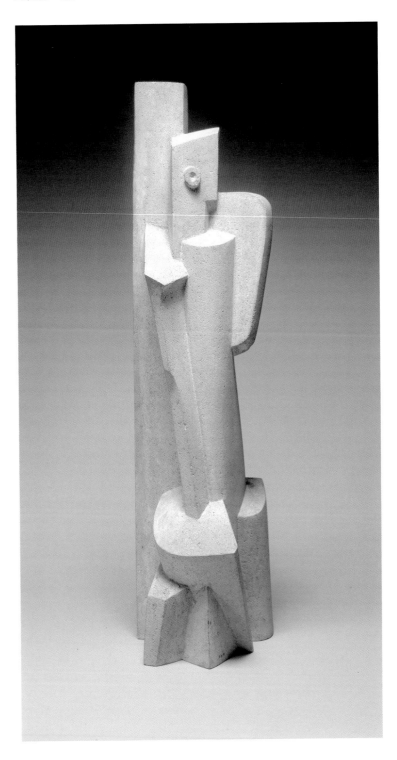

Plate 13

Henri Gaudier-Brzeska (French, 1891–1915)
Hieratic Head of Ezra Pound, 1914
Marble, 35 5/8 x 18 x 19 1/4 in.
(90.5 x 45.7 x 48.9 cm.)

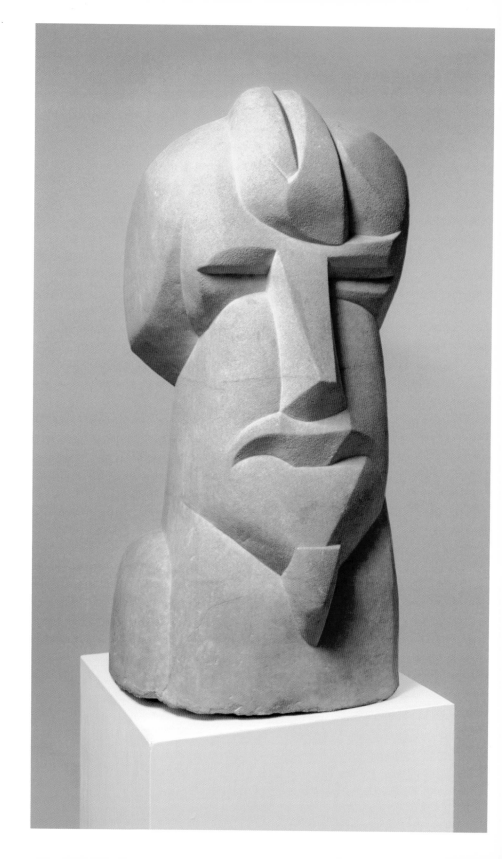

Plate 12

Raymond Duchamp-Villon (French, 1876–1918)
Large Horse (*Le Cheval majeur*), 1914
(enlargement, fabricated 1966)
Bronze, 59 1/2 x 57 x 34 in.
(151.1 x 144.8 x 86.4 cm.)

"*The Large Horse* is the most important of several works that we own by Duchamp-Villon, who was the brother of Marcel Duchamp. It relates to the new industrial age and basically turns a horse into a power plant. It even resembles a jet engine from some angles. Patsy, at first, did not care for the work as much as I did, but she eventually came to love it, too." – R.N.

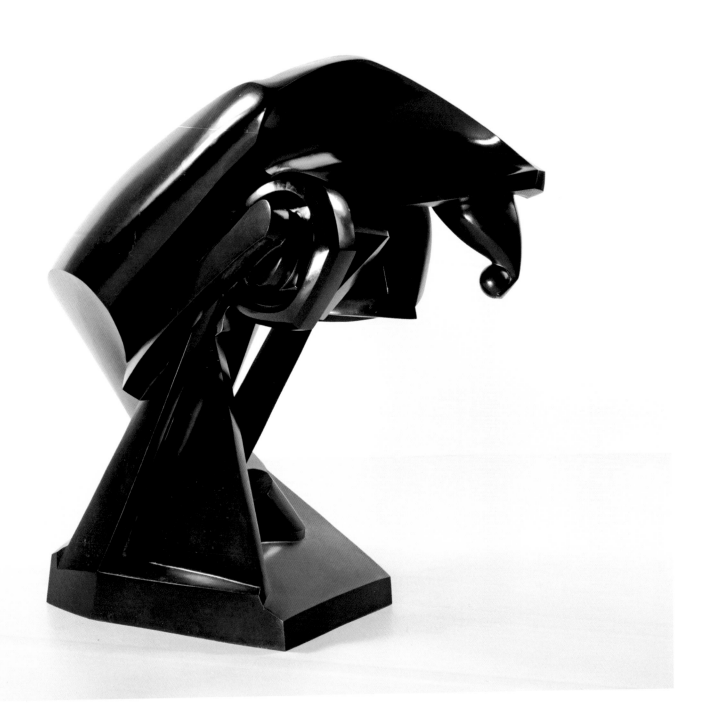

Plate 11

Gaston Lachaise (American, born France, 1882–1935)
Elevation (*Standing Woman*), 1912–27 (cast 1964)
Bronze, 70 3/4 x 30 x 19 9/16 in.
(179.7 x 76.2 x 49.7 cm.)

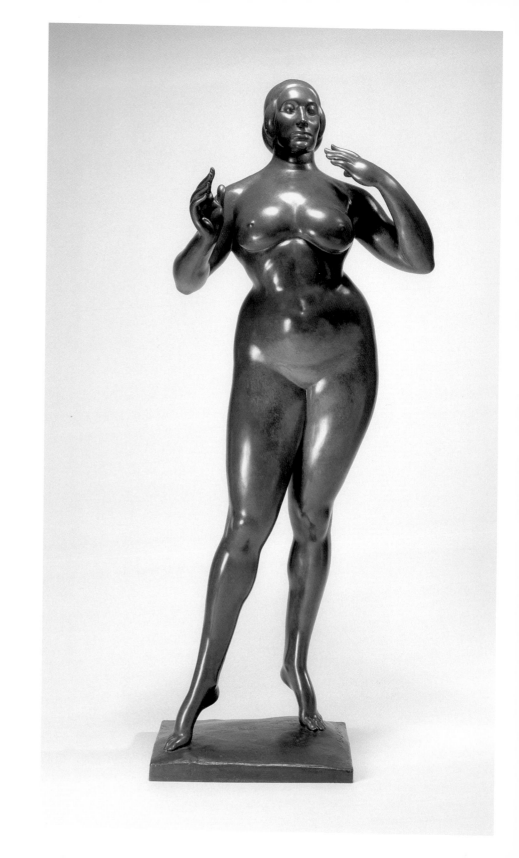

Plate 10

144/145 Catalogue

Pablo Picasso (Spanish, 1881–1973)
Head of a Woman (*Tête de femme*), 1958
Gravel and concrete,
120 1/8 x 43 1/4 x 55 7/8 in.
(305.1 x 109.9 x 141.9 cm.)

"I was able to buy this piece about two years ago. I was flying back from Turin and a working meeting with Renzo Piano about the building. I traveled to the outskirts of Paris and saw the sculpture installed in the garden of a private home and fell in love with it. This was Picasso's first concrete piece, which made it very unique and special." – R.N.

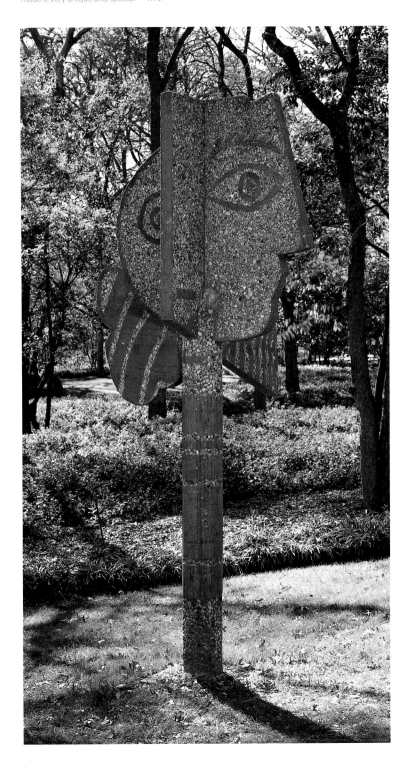

Plate 9

Pablo Picasso (Spanish, 1881–1973)
Head of a Woman (*Tête de femme*), 1931 (cast 1973)
Bronze, 34 x 14 3/8 x 19 1/4 in.
(86.4 x 36.5 x 48.9 cm.)

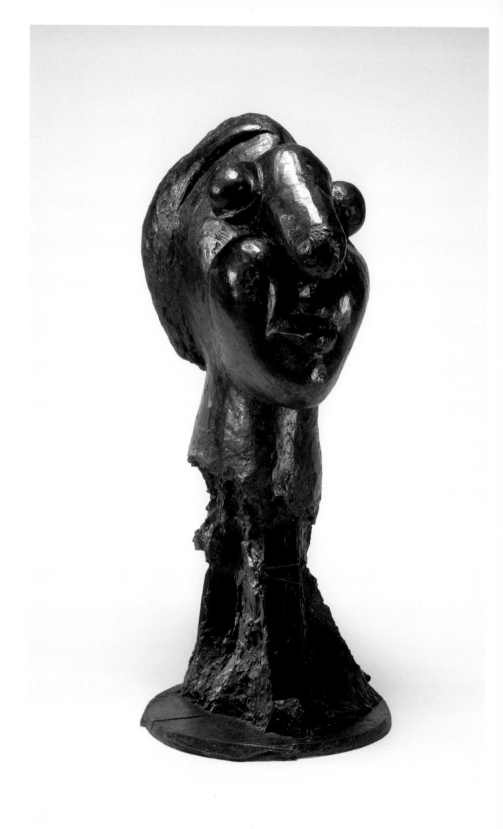

Plate 8

142 / 143 Catalogue

Pablo Picasso (Spanish, 1881–1973)
Head (*Fernande*)
(*Tête de femme* [*Fernande*]), 1909
Plaster, 18 1/2 x 14 1/8 x 13 3/4 in.
(47 x 35.9 x 34.9 cm.)

"This is the beginning of Cubist sculpture, Cubism from the point of view of working in sculpture. Picasso was a young man at the time, and Fernande was his companion. You can really sense the artist's hands working, taking the slabs of material and building up the form, cutting out the eyes, and shaping the nose and mouth forms." – R.N.

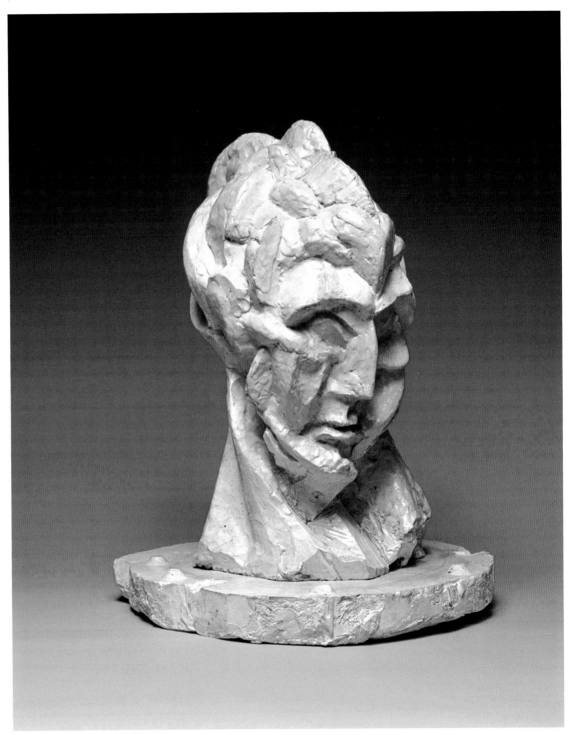

Plate 7

Constantin Brancusi (French, born Romania, 1876–1957)
The Kiss (*Le Baiser*), 1907–08 (cast before 1914)
Plaster, 11 x 10 1/4 x 8 1/2 in. (27.9 x 26 x 21.6 cm.)

"My wife and I felt that this was truly one of the great revolutions in modern sculpture because Brancusi was able to take a block and create a truly emotional experience. The timeless meaning of the interlocking figures is presented in this modern form. At our house we display it on the dining room table making it part of the environment and connecting it to the rest of life." – R.N.

Plate 6

Aristide Maillol (French, 1861–1944),
Night (*La Nuit*), ca. 1902–09 (cast 1960)
Bronze, 41 x 42 x 22 1/2 in.
(104.1 x 106.7 x 57.2 cm.)

"I first saw a cast of this piece in lead in the Tuilleries Garden at the Louvre in Paris. It's a superb image of a woman dreaming, greatly influenced in its cubic form by Egyptian art. Most people don't realize that her face is very beautiful. You have to get down low and look up into the sculpture to see it, which we always advise people to do." – R.N.

Plate 5

Henri Matisse (French, 1869–1954)
Large Seated Nude (*Grand nu assis*), 1922–29 (cast 1952)
Bronze, 30 1/2 x 31 5/8 x 13 5/8 in.
(77.5 x 80.3 x 34.6 cm.)

"This work is very different from any others by Matisse – it is almost a balancing act. The figure supports itself in this incredible pose, which is full of angles and tension. The legs are locked together, the torso projects out into space, and the arms are raised behind the head, all adding to the dynamic composition." – R.N.

Plate 4

Henri Matisse (French, 1869–1954)
The Serf (*Le Serf*), 1900–04 (cast ca. 1912)
Bronze, 36 3/8 x 13 1/4 x 12 3/8 in.
(92.4 x 33.7 x 31.4 cm.)

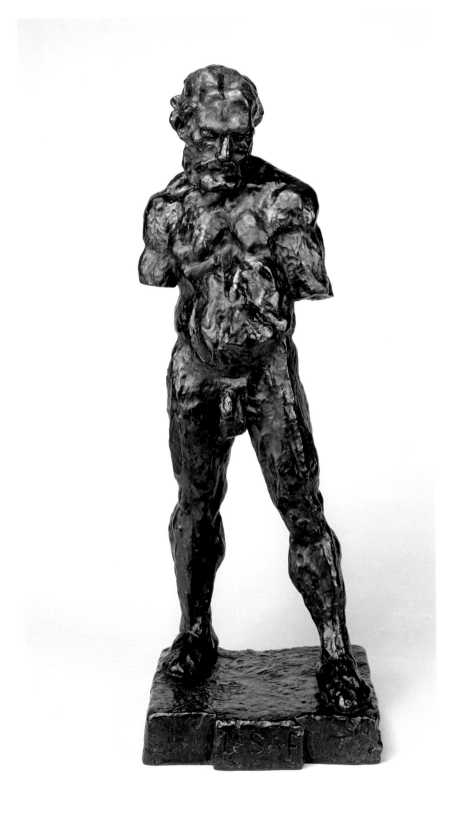

Plate 3

Paul Gauguin (French, 1848–1903)
Tahitian Girl, ca. 1896
Wood and mixed media, 37 3/8 x 7 1/2 x 8 in.
(94.9 x 19.1 x 20.3 cm.)

"This piece was one of relatively few sculptures Gauguin made. He made it in Tahiti where it was acquired by a French sailor who took it home to France. It remained in the sailor's family for 80 years and was almost totally unknown before we acquired it. Gauguin was able to transfer almost magically one of the beautiful faces in his paintings into this lovely wood carving." –R.N.

Plate 2

Medardo Rosso (Italian, 1858–1928)
The Golden Age
(*L'Eta d'oro*; also called *Aetas aurea*), 1886
Wax over plaster, 19 x 18 1/4 x 14 in.
(48.3 x 46.4 x 35.6 cm.)

"Rosso worked around Milan in the 1880s and 90s. He is one of the few sculptors of the era to use wax as his primary medium, and he developed a formula that has allowed his works to survive in good condition for over 100 years. There is an inner light to the wax that is totally unique. We were able to assemble the largest collection of waxes by Rosso in any collection in the United States."
—R.N.

Plate 1

Auguste Rodin (French, 1840–1917)
The Age of Bronze (*L'Age d'airain*), ca. 1876
Plaster, 71 1/2 x 25 1/2 x 21 1/4 in.
(181.6 x 64.8 x 54 cm.)

"This is the earliest work in the collection, the great *Age of Bronze* by Rodin. There are many bronze casts, but casts in plaster are very rare. Although fragile, it is in perfect condition except for a slight crack. Rodin worked the plaster with his hands and then used it to make bronzes." –R.N.

Notes

For the titles of all works, the most common or preferred title in English is given first, followed by foreign language or alternative titles in parentheses.

For the dimensions of all works, height is given first followed by width followed by depth.

Commentaries by Raymond Nasher are presented on selected works and designated with the initials "R. N." These quotations are extracted from interviews with Mr. Nasher conducted in 1997 and 2003.

Catalogue

Notes

For illustrations of works of art in the Nasher Collection not reproduced in this book, reference should be made to two catalogues that accompanied exhibitions of the collection, *A Century of Modern Sculpture: The Patsy and Raymond Nasher Collection* (Dallas: Dallas Museum of Art; New York: Rizzoli, 1987), and *A Century of Sculpture: The Nasher Collection* rev. ed. (Dallas: Nasher Foundation, 2003)

1. Quoted in Garnett McCoy, ed., *David Smith* (New York: Praeger, 1973), 82–83.

2. Letter, Duchamp-Villon to Walter Pach, January 16, 1913, in Pach, *Raymond Duchamp-Villon, Sculpteur, 1876–1918* (Paris: Imprimerie Crozatier, 1924), 19.

3. Guillaume Apollinaire, *Les Peintres cubistes: Méditations esthétiques* (Paris: Eugène Figuière, 1913), 15.

4. Michel Leiris, "Alberto Giacometti," *Documents*, no. 4 (September 1929): 209–10.

5. Michel Leiris and Jacques Dupin, eds., *Ecrits/Alberto Giacometti*, 2d ed. (Paris: Herrmann, 1997), 273.

6. Margit Rowell, ed., *Joan Miró: Selected Writings and Interviews* (Boston: G. K. Hall and Company, 1986; reprint, Cambridge, Mass.: Da Capo Press, 1992), 175.

7. William S. Burroughs, in *Helnwein*, exh. cat. (Vienna: Niederösterreichisches Landesmuseum, 1991), preface.

to quote David Smith again, constitutes "an adventure viewed." It also leaves little doubt about the capacity of modern sculpture to suggest, comment, inspire, and create powerful metaphors for illuminating our shared humanity. While solid and mostly static in form, these works come to life as embodiments of meaning, not through a window of illusion, but by direct confrontation in the viewer's own time and space. The new Nasher Sculpture Center, featuring selective rotations of works from the Nasher collection, will provide a splendid showplace for these adventures in looking, feeling, and understanding.

Fig. 24 Antony Gormley (British, born 1950)
Three Places, 1983
Lead, fiberglass, and plaster
Lying: 12 x 80 3/8 x 20 5/8 in.
(30.5 x 204.2 x 52.4 cm)
Sitting: 39 x 52 1/4 x 22 1/2 in.
(99.1 x 132.7 x 57.2 cm)
Standing: 13 1/4 x 74 7/8 x 20 1/2 in.
(33.7 x 190.2 x 52.1 cm)

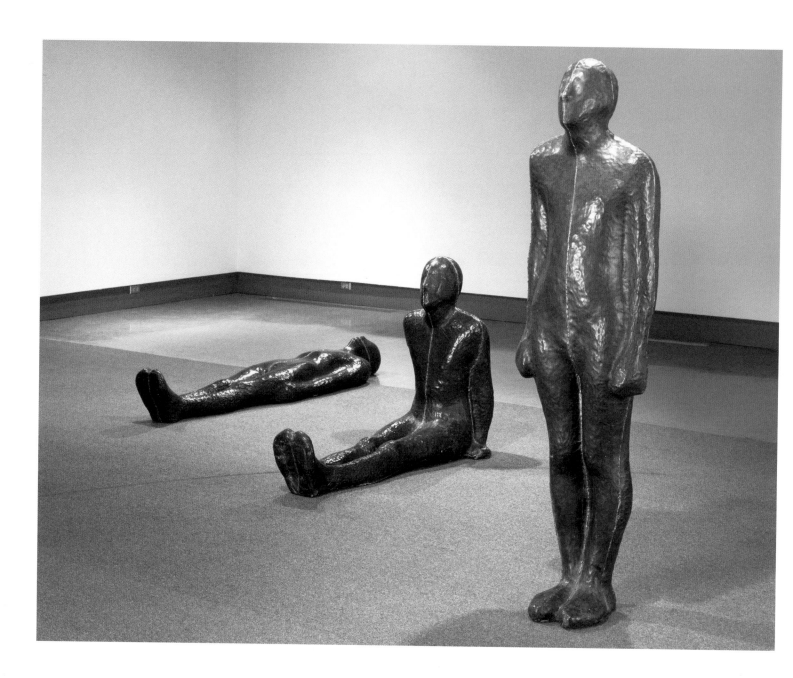

Jeff Koons's *Louis XIV* (pl. 46) lands us squarely in a postmodern realm of irony and commodification of the body. An antique-store bust, a found object, is enlarged and cast in stainless steel. Its gleaming surface is at once a part of the artist's fetishistic devotion to finish—a reference to the polished chrome beloved by car buffs—and a send-up of the dignity of his royal subject. Person is converted into thing, while Koons's hands-off approach to art making, in which all process is left to fabricators, pointedly calls into question issues of originality, craft, and creativity, just as Warhol's commercial production methods had decades earlier.

These works illustrate just a few of the ways the figure has thrived in modern sculpture as a vehicle to explore new formal languages, diverse aspects of human experience, and even the lure of pop culture. In our postmodern era, when the influence of Conceptual, performance, and photo-based art has keyed a trend toward de-materialization of the sculptural object, the body continues to be a viable touchstone for creativity. Video artists use the figure routinely in their filmic constructions. Performance art almost by definition is body-oriented. And such object-based sculptors as Gormley (fig. 24), Abakanowicz, Koons, Joel Shapiro, Louise Bourgeois, and Kiki Smith, among others, continue to elicit new meanings from figural references. As the most common denominator of human experience and the tool with which we negotiate in so many ways the world around us, the body is and always will be a prime theme for empathy and understanding in art.

Although brief, this thematic overview of the Nasher collection shows both the variety of its holdings and the depth of representation of key trends and artists. Far from static, the collection continues to grow, with new acquisitions added regularly. In its totality, it approaches a textbook survey of the history of modern sculpture and provides insights into the radical rethinking of sculptural principles by artists during the past century that,

hand as an abstract assemblage of three nestled forms and, on the other, as a segment of backbone that stands remotely for the entire figure. In either case, the joy of the sculpture lies in the intricate flowing movements that the eye follows as shapes curve in and around themselves and toward and away from neighboring masses. These patterns weave three dimensionally and can only be comprehended if one walks fully around the sculpture. The tactile attractiveness of the work—an essentially erotic desire to understand through touch—is particularly strong. As is almost always the case with Moore, articulation of active surrounding space is just as important as the articulation of mass itself.

With de Kooning's *Clamdigger* (pl. 37), his only large-scale plaster still in existence, abstraction and figuration are locked in dynamic tension. A nude figure confronts us frontally, a shovel held in one hand (probably an allusion to the digging of clams that took place in the ocean shoals close to de Kooning's studio in Southampton, New York). It is not a static figure, however, but one activated by the kneading, cutting, and pulling action of the artist's hands, so that the whole figure quakes with an elasticity that suggests not solid material but protoplasm. The painterly manipulation of surface relates directly to the gestural intensity of de Kooning's contemporaneous paintings. This pictorial quality is furthered by the varied tones of golden patina, achieved through a combination of shellac and soap, unique within de Kooning's surviving oeuvre. In contrast to the rock-solid stability of Brancusi's figures in *The Kiss*, the *Clamdigger*'s quivering posture projects some of the precariousness and ambiguity that can characterize modern consciousness of the body, and that certainly permeate de Kooning's exploration of bodies, mostly female, in his paintings as well.

A much different paradigm of sexuality and fertility is found in Gaston Lachaise's *Elevation* (pl. 11). Whereas the last works speak of male possession and domination, *Elevation* is a worshipful celebration of Lachaise's ideal of feminine beauty, based only very distantly on his model, his wife, Isabel. The upper body, abdomen, and hips are robustly proportioned but sleekly modeled, in a modern variation on ancient fertility idols. That the woman stands so daintily on her toes, however, gives her a sense of lightness and levitation. The raised arms and closed eyes recall the pensive state of Rodin's *Age of Bronze*, but the inwardness here seems a part of an almost hypnotic meditation on femininity and its splendid physical embodiment. The mood is one of reverence and even faith.

In contrast to the natural description inherent in varying degrees in these last works, sculptures in the Nasher collection by Constantin Brancusi, Henry Moore, and Willem de Kooning show figuration pushed to more extreme levels of abstraction. Brancusi's *The Kiss*, for example (pl. 7), is only minimally hewn from a solid cubic mass, critiquing in its archaic simplicity the elaborate and painterly naturalism of Rodin's famous *Kiss* and referring simultaneously to Egyptian cube figures. Despite the ideational reductiveness with which Brancusi's man and woman are rendered, they still manage to convey a sense of genuine tenderness.

Moore's *Working Model for Three Piece No. 3: Vertebrae* (pl. 32) started as a maquette made of three loosely grouped flints. The Nashers had seen Moore experimenting with the three stones in his studio at Much Hadham, England, and voiced interest in acquiring the sculpture once it reached fruition. About a year later they received a call from Moore announcing that it was done and available.

As a variation on his signature theme of the reclining figure, Moore created a composition that reads on the one

Fig. 21 Henri Matisse (French, 1869–1954)
Madeleine I, 1901 (cast 1903)
Painted plaster, 23 3/4 x 9 1/2 x 7 1/2 in.
(60.3 x 24.1 x 19.1 cm.)

Fig. 22 Henri Matisse (French, 1869–1954)
Reclining Nude I (*Aurora*) (*Nu couché I* [*Aurore*])
1907, Bronze, 13 1/16 x 19 3/4 x 11 in.
(33.2 x 50.2 x 27.9 cm.)

Fig. 23 Pablo Picasso (Spanish, 1881–1973)
Pregnant Woman (*La femme enceinte*), 1950–59
Bronze, 42 3/4 x 11 3/8 x 13 1/4 in.
(108.6 x 28.9 x 33.7 cm.)

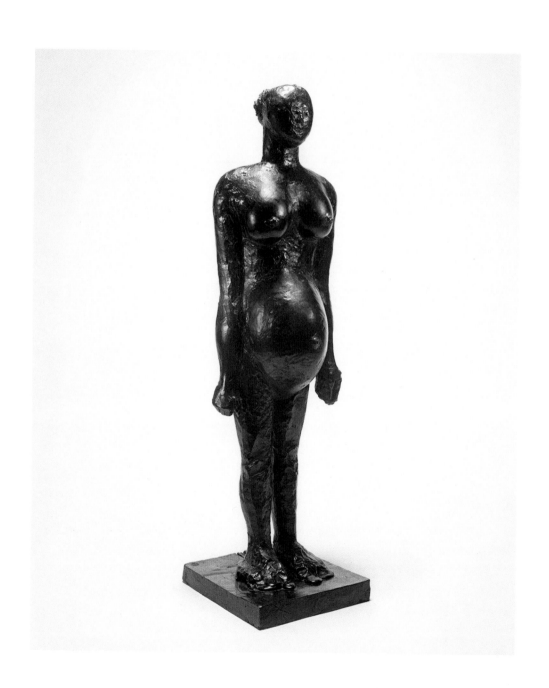

contrary to that encouraged by the painterly ease and richness inherent in the odalisques, one emphasizing solidity of mass and harshly demarcated shapes. Or is it possible that these sculptures, and others by Matisse with similar stylizations such as *Jeannette V* and *The Back III*, show traces of an ambiguous or somehow conflicted attitude toward the female body? In either case, they are marked by a distinct expressive voice much different from what is generally found in the paintings.

Like those of Matisse, Picasso's sculptures most often depict women, with very few men appearing plus some animals and still lifes. In both his *Head of a Woman*, one of the series of so-called Boisgeloup heads named after the location of Picasso's country château where he made them, and his later *Pregnant Woman* (pl. 9, fig. 23), the themes revolve characteristically around sexuality and its issue. *Head of a Woman* is a depiction of Picasso's mistress at the time, Marie-Thérèse Walter. With his usual flair for invention, however, the head and facial features are stylized into rounded, tumescent masses, stressing the qualities of fleshiness and fertility fundamental to Picasso's internal image of his lover. That he transformed nose and eyes into forms suggestive of male genitalia only reinforces the heated eroticism that underlies the portrait, essentially a provocative caricature of love and lovemaking that dares to equate lust with forms of raw, primitive power.

With his *Pregnant Woman*, wittily constructed from ceramic bowls to form the distended stomach and breasts, Picasso invoked the totemic powers of sculpture, partly out of superstition and partly as a joke. According to Françoise Gilot, who was living with Picasso at the time and who had already given birth to two children by him, it depicts her pregnant with a third child, as a wish fulfillment for the artist concocted with mock seriousness. Fully serious, however, was Picasso's quest for ever-changing ideas on ways to image the human body.

tion such as *The Serf* and *Madeleine I* (pl. 4, fig. 21) show Rodin's impact but also Matisse's own sculptural personality in formation. The choice of expressive figuration as a language, use of the partial or fragmented figure, the lack of traditional narrative or symbolic accoutrements, the combination of a forceful silhouette with richly modeled and inflected surfaces, emphasis on the body's structural integrity—these are all shared characteristics. Matisse's push beyond Rodin, however, is seen in the exceptionally aggressive, distorted modeling of *The Serf*'s torso and back and the emphatic generalization of *Madeleine*'s silhouette to form an upward-spiraling S curve.

The later *Reclining Nude I* and *Large Seated Nude*, also in the Nasher collection (fig. 22, pl. 5), both of which treat traditional poses of feminine beauty and allure, show the degree to which Matisse finally was willing to depart from naturalism in his depictions of the human form. In both cases, some parts of the body are exaggerated in proportion and others condensed in the interest of creating a powerful compositional rhythm that engulfs the figures, a clear demonstration of Matisse's famous dictum that expression in a figure is conveyed, not by facial features or gesture, but by the whole arrangement of the form. Anatomical modeling follows its own expressive momentum and logic. Both figures are heavily masculinized, with powerful physiques, overly rounded breasts, a rock-hard cranium in the case of the *Large Seated Nude*, and tense musculature. Both strike us as hard-bodied amazons, physically and temperamentally at odds with their poses of proffered receptivity. No modern artist is more completely identified with sensuality and lyrical beauty than Matisse. Yet, the compositional handling of these two nudes yields a norm of beauty much different from what we see, for example, in the compliant, softly rendered odalisques of Matisse's paintings from the so-called Nice period, roughly contemporaneous with the *Large Seated Nude*. The physicality of sculpture may have given vent to an idea of the female form

eyes while waving at us energetically with outspread hands, and also in many Pop Art objects. Oldenburg's *Typewriter Eraser*, for example (pl. 39), expands a simple (but no longer commonplace) object to surprising, gargantuan scale while also giving it a hint of anthropomorphism in the long bristles blowing like hair. As with the *Gossiper II*, we suddenly find ourselves in a Swiftian world of exploded dimensions that confuses our own internal sense of size. Lichtenstein's *Double Glass* (pl. 41) plays similar tricks on perception and expectation. It represents two glasses with liquid in them but is solid bronze rather than fragile glass, two dimensional rather than three, and open to the air rather than enclosed in structure. Art of this type pushes us off-stride and out of mental ruts. We are reminded of William Burroughs's declaration that "the function of the artist [is] to evoke the experience of surprised recognition: to show the viewer what he knows but doesn't know that he knows."[7]

The Evocative Body

From this arena of fantasy and surprise we move finally to the oldest theme in sculpture, the human body, to examine some of the ways that modern artists have explored the seemingly inexhaustible possibilities of expression and formal innovation that it inspires. Despite ongoing assaults on figuration waged by different abstract movements throughout the twentieth century, the human body has remained not just a viable but also a necessary vehicle for sculptural invention, actually gaining urgency and topicality through cross-fertilization with various forms of abstraction. Use of the figure has already been seen as basic to expositions on the modern self and to the Surrealist imagination. Numerous other meanings and purposes can also be cited within the Nasher collection.

Rodin's important legacy for the figurative tradition in modern sculpture was most directly and strongly perpetuated around the turn of the last century by the young Henri Matisse. Early works by Matisse in the Nasher collec-

Calder's early work, while based to a large degree on Constructivism and technology, also came under the sway of Surrealism, especially the whimsical, biomorphic, free-floating forms in paintings by Miró. In his *Spider* (pl. 19), a standing mobile, Calder makes witty reference in the long, hanging wires and pods to both vegetation (branches and leaves) and the leggy structure of arachnids. Noguchi's *Gregory* (fig. 7) has a similar quality of double or triple entendre. It is basically a standing figure composed of flat, rounded forms that look back directly to a long series of drawings and paintings of bone figures that Picasso produced in the late 1920s. The pieces of the figure are not welded, however. They slip together and are held by gravity and notches, giving a peculiarly unstable and puzzlelike quality to the composition that promotes a more abstract reading and introduces an ambiguity of spectatorship, tempting viewers to touch and manipulate.

Another member of the Surrealist group who, like Miró, kept his distance from its tendency toward morbidity and psychodrama was Jean Arp. Although produced relatively late in his career, *Torso with Buds* from 1961 (pl. 27) has many of the earmarks of his earlier, Surrealist-related work of the 1930s. Its tall, biomorphic shape, swelling and narrowing as if in response to different internal pressures, seems to be part plant and part animal or human. Arp equated artistic impulse with the generative force of nature. He wanted his sculptures to look as if they had grown naturally, as the product of unconscious actions of his hands and mind. Their beautifully honed surfaces, however, show just how much he remained in ultimate control. This work was the first important modern sculpture acquired by the Nashers and stood for many years as a welcoming presence just inside their front door.

In more recent decades, wit and imagination have commingled, for example, in Jean Dubuffet's large *Gossiper II* (pl. 34), a comical giant seated on a chair cast from polyester resin that seems to wobble and quake before our

imagination, it relates to a series of paintings Miró had done earlier on nocturnal themes and gives massive physical embodiment to musings on animals or phantoms of the night. Miró had indicated that through sculpture he could create "a truly phantasmagoric world of living monsters,"[6] but *Moon Bird* is far more whimsical and erotic than threatening.

With his *Caress of a Bird* (pl. 23), Miró takes a different compositional tack, creating a tall, skinny, gawking figure out of an odd assortment of found objects—a straw hat for the head, a toilet seat for the upper torso and shoulders, an ironing board for the lower body, and a tortoiseshell for the abdomen or female sex—all freely associated in the way that Surrealists used disparate objects in combination to spark mysterious or evocatively poetic dialogues. Miró's approach, however, is more humorous, with brightly painted surfaces to augment the spirited sense of ribald joie de vivre and two bocci balls added at the back as diminutive buttocks, a final humorous note.

The King Playing with the Queen (pl. 21) by Ernst is harder to read in terms of mood or intent. For an aura of magic, Ernst turned to sources in so-called primitive art. A half-length male figure, whose head and horns—a symbol of power—are modeled after African or Native American masks, hovers over a game board, moving with one hand a small geometric game piece, identifiable from the title as a queen, while hiding behind his back a similar piece. The overall image strikes us at first as amusingly playful. A more sinister interpretation is also possible, however, one involving male domination of females and willful manipulation, a reading not at all incompatible with the sexual politics of Surrealism. The iconography of the game board is also a favorite Surrealist trope, intimating both mental agility and chance, and has already been seen in another manifestation in Giacometti's *No More Play* (fig. 19).

ranks, seemingly captives in prisons or concentration camps, isolated and frozen in time. Often, as in *Bronze Crowd*, they are headless and formed as empty shells—with just the skin of the figure, roughly or even aggressively modeled and shaped, recalling the presence of a former person. Specifics of narrative are withheld, expanding the amplitude of references each of us brings to the work, but vulnerability, hallowness, and distressed forms add up to an unmistakable and unsettling quality of *terribilità*.

As commentary on the human condition, such works may be disconcertingly grim, even portentous, but are nevertheless honest and revealing. Their lasting evocative power is due to the strength of each artist's formal language but also to the fact that they do not overdescribe. They continue to appeal to our interpretative imagination and thus belie Baudelaire's doubts that sculpture can rise poetically above its inert concreteness. Within the Nasher collection are many other fine examples of sculpture's suggestive powers. In one group, for example, artists create through fantasy and imagination their own parallel realms of existence. In another, the age-old theme of the human body is reinvented to explore such basic human ideas and experiences as birth and renewal, beauty, hope, and sexuality, all in the context of new formal investigations.

Worlds of Fantasy and Imagination

The Dada and Surrealist art movements of the 1920s opened doors to fantasy, chance, and the human subconscious as much for sculpture as for painting. For artists attempting to push sculpture through these doors, however, the sculptural problematic of overcoming static, literal form was especially challenging. Different sculptors developed various strategies for this journey into the mind's eye. Miró, for example, freely invented his own zoological species. *Moon Bird* (pl. 22) has no progenitors in art history or natural science. Purely a figment of his

Whereas Giacometti's figures seem withdrawn and even timorous, those of George Segal robustly engage the ups and downs, ins and outs of everyday life. With *Rush Hour* (pl. 43), it is the "downs" that attract his focus. Segal, as is well known, took the molds for his works directly from the bodies of friends and acquaintances who agreed to pose for him. In the working process he freely edited, manipulated, and generalized the forms, giving them cohesiveness and greater visual strength. Enough realism of detail survives, however, to endow the figures with a convincing, haunting presence. In *Rush Hour*, six pedestrians walk to or from work, acting out a daily ritual with a solemnity and processional density that recall Rodin's *Burghers of Calais* and certain medieval processional sculptures. The dark patina, applied with spontaneous passages of drips and tonal variation by Segal himself, adds to the general mood of exhaustion and dejection. In our atomized society, safety of numbers cannot assuage the sting of individual loneliness. Certain painters of the Depression era had tackled through their Social Realism similar themes of dehumanization and entrapment in the workplace. Segal is one of the few modern sculptors, however, to handle themes of social consciousness so expressively, not just in this but in numerous other works as well.

Another is Magdelana Abakanowicz. Abakanowicz's focus is much different, though, shifting from the realities of everyday life to universal themes of suffering and despair. Having lived in Poland during World War II and the subsequent era of Soviet control, she has extensive personal experience with human destitution and material scarcities and has witnessed powerful government forces at their most destructive. Her work over the last few decades, including the large *Bronze Crowd* in the Nasher collection (pl. 49), alludes indirectly but strongly to these chapters in her life. Made of bronze or burlap, Abakanowicz's figures generally stand, kneel, or sit in long

It is Giacometti's figurative style, however, as it evolved during and after World War II, that encompasses his best-known work and the work for which he drew a reputation for existentialist affinities.

His highly attenuated, roughly modeled figures, such as *Venice Woman III* (fig. 20), or the tiny *Two Figurines* seem to speak of frailty, vulnerability, and attendant mental states. Giacometti himself disclaimed such interpretations, asserting that he was concerned mainly with problems of perception: what we see, how we see it, and how visual impressions relate to what is known or felt.

Such phenomenological concerns drove the element of seriality or repetition in Giacometti's work, whereby he repeated portraits or depictions of certain figures many times over, sorting out his shifting impressions and arresting in any one version the particularities of vision that applied at that specific juncture. For all the emphasis on sustained study of an individual's features, however, Giacometti's methodology necessarily involved psychological dimensions. As he remarked famously, he was interested in the "residue of vision":[5] what afterimages lingered as he transferred his gaze from subject to sculpture, and how these images are affected by personal feeling, memories, and other subjective contingencies. Nothing is static or permanent, he seems to assert through his sculptures, and nothing about perception is absolute, certainly meaningful precepts for modern life. With Giacometti's painted bronzes, such as the three portraits of his brother Diego in the Nasher collection (pl. 17), he returned to his figures after they had been modeled, molded, and cast. Working from memory, he applied thin washes of subdued color, adding quite literally another layer of spontaneous, intuitive interpretation. Overall, his sculptures record not so much an outward appearance as the body of sensations that influence how we see and respond to others.

child in *The Golden Age* and the sick boy in *Bambino malato*. In Aristide Maillol's *Night* (pl. 6), a deep somnam-
bulism is made physically manifest by the figure's heavy proportions and compact pose. Maillol made reference
to the geometric clarity of poses in Egyptian art, which he greatly admired, and also to Symbolist themes of
sleep as a creative, transformative state that carries one far from the realities of everyday life. As viewers we are
pulled into the mood of reverie and begin to wonder where the woman's inner voyage of dreams is taking her.

With Duchamp-Villon's *Baudelaire* of 1911 (fig. 18), all outward display of emotion or communication is wiped
clean from the frozen, pointedly Egyptian countenance of the figure and projected inward instead. Behind
Baudelaire's blank eyes, we sense tremendous concentration and mental power. It is a portrait not so much of
the man as of intelligence per se, and of the life of the mind. The reference to ancient devotional or political
imagery is purposeful. Duchamp-Villon's deification of Baudelaire in an age of secularism proffers something
meaningful in which to believe—intellect and human creativity.

Outer human form is generally seen as a key to inner life also in the work of Alberto Giacometti, although in
much different terms. Of all the camps and movements that populate the history of modern art, that of
Surrealism had the greatest claim on the human subconscious as its rightful domain, and Giacometti's main
formative impetus came through Surrealism. Several works in the Nasher collection show its imprint, including
the large and totemic *Spoon Woman*, the eerie *Cubist Head*, and the marble and wood *No More Play*, an essay
on death and the destructiveness of war (pl. 16, fig. 19). These and other works of the Surrealist period probe a
mysterious inner world of primal fears, urges, and desires, often hitting particularly empathetic and disturbing
notes, what the poet Michel Leiris called "a sudden communication between [the object] and our hearts."[4]

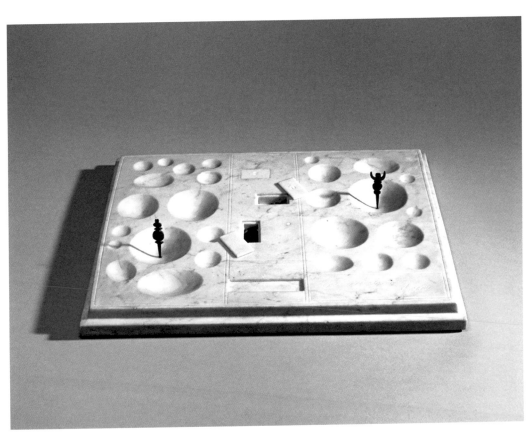

Fig. 16 Auguste Rodin (French, 1840–1917)
Eve, 1881 (cast before 1932)
Bronze, 68 x 17 1/4 x 25 1/2 in.
(172.7 x 43.8 x 64.8 cm.)

Fig. 17 Medardo Rosso (Italian, 1858–1928)
Sick Child (*Bambino malato*), 1889
Wax over plaster, 10 5/8 x 10 x 7 1/4 in.
(27 x 25.4 x 18.4 cm.)

Fig. 18 Raymond Duchamp-Villon (French, 1876–1918)
Baudelaire, 1911
Plaster, 16 x 8 7/8 x 10 1/8 in.,
(40.6 x 22.5 x 25.7 cm.)

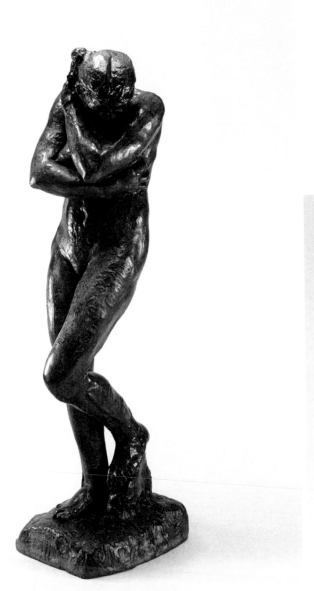

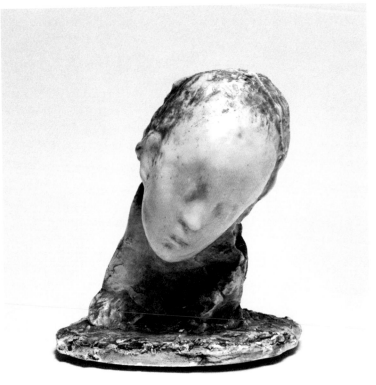

defining the modern self, or modern psyche, as do rationality and intellect, and mental states of dissonance and conflict are all too common a part of life in the twentieth and twenty-first centuries. Traditional sculpture dealt frequently with such human themes as love, triumph, and sorrow. Modern sculptors have probed more deeply into psychological realities of the self and its other and their negotiations with modern life.

Although it dates from about 1876, Rodin's *Age of Bronze* (pl. 1) is a harbinger of later struggles to deal honestly with these internal realities. In his early studies for the work, which he first titled *The Vanquished*, Rodin had equipped his model with a spear, held vertically as a brace in his left hand, which adds a narrative dimension associated with the recent Franco-Prussian War. By eliminating the spear and changing the title, he created ambiguity of meaning, itself a modernist strategy, and also focused attention compositionally on the upward tilt of the head, raised arm, and closed eyes, all of which contribute to a sense of contemplation or epiphany. Even while looking back to stylistic precedents in Donatello and Michelangelo, the sculpture broaches issues of awakening or heightened consciousness that are key to the modern spirit.

Depth of emotion and ambiguity of psychological state characterize several other works in the collection dating from the late nineteenth and early twentieth centuries. Rodin's *Eve* (fig. 16), viewed as an independent sculpture separate from its original biblical context with Rodin's *Adam* and *Gates of Hell*, is a powerful emblem of personal anguish and despair. Several works in wax by Medardo Rosso examine shadowy realms of perception and mood (pl. 2, fig. 17). The figures, with their generalizations of form and soft reflectivity and translucency, appear shrouded in hazy atmosphere and seem to question what it is that the eye actually is able to define. Emotionally, the figures are also withdrawn, with a strained psychological state weighing, for example, over the mother and

grander scale. This was the first of Picasso's large outdoor sculptures, following years of drawings and paintings in which he yearningly explored designs for monumental open-air compositions.

In more recent decades, paradigms of science and mathematical thought continued to hold the attention of certain artists, sometimes on an advanced level. Obvious applications are found in the technology-based work with video, light, and sound pursued by Dan Flavin, James Turrell, Naum June Paik, Bill Viola, and many others. Mark di Suvero, Anthony Caro, and Joel Shapiro (pls. 28, 51, 53) developed personal variations on languages of industrialized, constructed form stretching back to the time of the Russian Revolution but now revitalized. For artists such as Richard Serra, Donald Judd, Tony Smith, and Carl Andre, who explored the formal possibilities of highly reductive geometric mass (pls. 35, 36, 40, 29, 54), not only was a no-nonsense aesthetic of factory fabrication essential but so, too, were mathematical principles of progression and variation, seriality, and primary or indivisible states. In a contemporary expression of some of the same ideas that Gabo had examined in his *Constructed Head No. 2*, Antony Gormley's *Quantum Cloud XX* (*tornado*) (pl. 52) deconstructs the human form in a way that again asserts the primacy of space and energy over solid mass. Or perhaps its main reference point, in its clusters of small bits of metal, is in the new computer technology of digitization.

The Modern Self

Science and its social applications in engineering and technology supported, especially at the beginning of the century, a positivist worldview in which discovery, progress, and analytic thought all contributed to a widely shared vision of an exciting new era. In an age of such rapid and disruptive change, however, distinctly different perspectives also found traction. Subjectivity, emotion, and deep self-consciousness have as much to do with

Fig. 15 Pablo Picasso (Spanish, 1881–1973)
Head of a Woman (*Tête de femme*), also called
Tête de Jacqueline, 1957
Painted steel, 30 3/8 x 13 3/4 x 10 1/8 in.
(77.2 x 34.9 x 25.7 cm.)

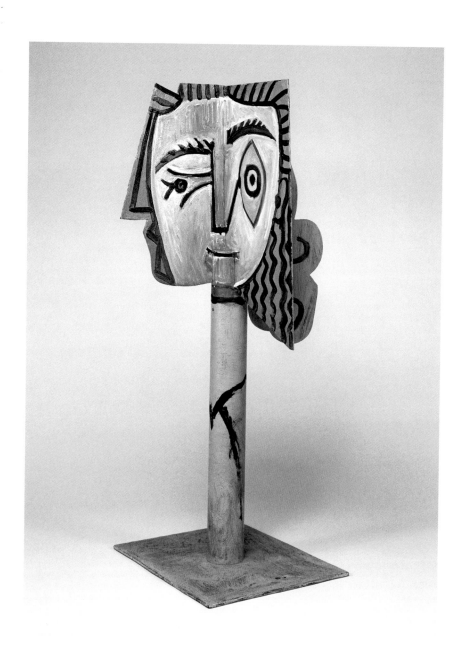

found around the factory. Two giant sheets of steel were cut out with free-form, curving outer edges and welded upright onto the long horizontal handle of a metal cart previously used for moving heavy objects. A slight gap between the sheets creates visual transparency and tension and reminds us of Barnett Newman's famous "zips" in his abstract paintings. The huge concavities in the outer edges of the sheets seem to allow space to press inward, forcefully activating the obdurate plates. A vertical tongue welded to the extremity of the cart's handle keeps the whole composition in alignment. Smith managed to turn raw materials into an evocatively complex image that speaks at once of modern industry and, through the reference to chariots, of Italy's classical past.

For Calder, who trained as an engineer, a similar enthusiasm for technology was inherent in his work from the beginning and sometimes involved motorized movement as well as bolted or welded constructions and the calibrations of spatial balance. His large-scale metal stabiles such as the *Three Bollards* (pl. 20) give steelworking a whimsical twist, producing biomorphic "creatures" that take on architectural proportions and convincingly combine nature and abstraction. Like Smith's work, they activate space by slicing cleanly through it. Their spatial dynamics are comprehended at first visually, through shaped silhouettes seen against backgrounds, and then bodily, through the act of walking around and through them, thus emphasizing the merger of both pictorial and physical qualities in Calder's work.

Picasso also contributed to the tradition of construction and assemblage. His painted steel *Head of a Woman* of 1957 (fig. 15) applies welded fabrication to a Cubist vocabulary of flat, intersecting planes that yield shifting perspectives of the same head from different angles. The closely related *Head of a Woman* of 1958 (pl. 10), made of concrete and gravel, uses techniques derived from the building and construction trades for similar effects on a

er Antoine Pevsner's *Dynamic Projection at Thirty Degrees* (fig. 14) fuses metal rods into curving, unfolding surfaces that invoke physical models for mathematical formulas.

Cubism also had scientific dimensions. While Picasso's examination of geometric form, shifting perspectives, and implied elements of time have to be seen as largely intuitive, other artists in the Cubist camp, especially some of those in the so-called Puteaux Group such as Albert Gleizes and Jean Metzinger, enthusiastically discussed and wrote about the implications of scientific principles for their art, including theories of relativity and the fourth dimension. The writer, theorist, and critic Guillaume Apollinaire's famous statement in 1913, that "geometry is to the plastic arts what grammar is to the art of the writer," [3] is indicative of the widespread artistic interest in mathematical principles. The clarity of geometric form found in sculptures such as Jacques Lipchitz's *Seated Woman* (pl. 14) was seen as an expression of Platonic purity and analytic thought and soon had profound influence on modern design and architecture. In a different stylistic vein, both González and Picasso (under González's tutelage) took modern fabrication techniques first explored by the Russian Constructivists (Gabo and his colleagues) to an advanced level. Their use of welding, soldering, and brazing allowed them to produce new morphologies of assembled metal parts, as seen in the *Woman with a Mirror* (pl. 18), which proved vastly influential for later generations. The incorporation of found objects and disparate materials in these open and airy yet rigid compositions greatly abetted freedom of invention. Among artists who elaborated on these themes around midcentury, David Smith and Alexander Calder stand out. Smith put the skills of a steelworker and foundry hand to the service of elegantly balanced compositions sometimes fully abstract but often partly figurative. His *Voltri VI* (pl. 26), for example, was made in an abandoned steel plant in Italy from parts

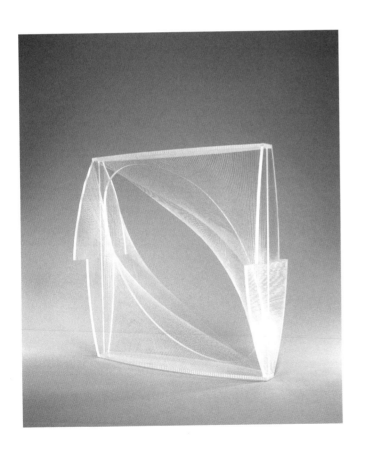

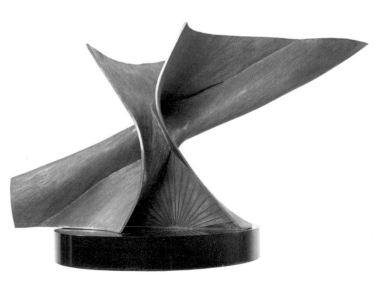

1913 that "the power of the machine asserts itself and we scarcely conceive living beings anymore without it."[2] The Italian Futurists created perhaps the most famous and extensive homage to technology with their graphic depictions of flight, speed, electricity, automobiles, trains, and even the machinery of war. Giacomo Balla and Umberto Boccioni both converted some of these new sign systems to three-dimensional form.

Returning to Duchamp-Villon, we find in the Nasher collection his most famous paean to mechanical power, the *Large Horse* of 1914 (pl. 12). Developed from models of rearing horses with riders, this work transformed through successive studies and modifications the anatomy of a horse into an image of churning gears, flywheels, and pistons, directly manifesting the contemporaneous evolution from horsepower to industrial might.

Naum Gabo's famous *Constructed Head No. 2* (pl. 15), first fabricated in small scale in galvanized iron and plastic in 1916 and 1923–24 respectively and then transformed by Gabo into a large, stainless steel version in 1975, is equally far reaching in its embrace of technology. Gabo was one of numerous artists working in Russia at the time of the Bolshevik Revolution who attempted to merge art with science and engineering to produce sculptures that engagingly symbolized reformations of the social and political order but also the transforming power of scientific thought. Gabo's interest in light, time, and space as sculptural elements, for example, was influenced by Ernest Rutherford's investigation of atomic structure and Albert Einstein's theory of relativity. The honeycombed structure of his huge *Constructed Head No. 2* references technologies for bridge and aircraft construction, substituting space for mass and a network of thin metal membranes for heavy supports. Gabo's exploration of lightness of structure, transparency, and modern materials resurfaces in a different guise in his *Linear Construction in Space No. 1* (*Variation*) of 1942–43 (fig. 13), made of plastic and nylon filament, while his broth-

duced and their purposes. Despite the anti-illustrational, non-narrative bias within most of modern sculpture, the efforts of artists to react meaningfully to historical events, commemoration, and celebration are also worthy of consideration.

As one alternative among many for surveying the Nasher collection and examining some of the more fertile ideas it manifests, a thematic review according to the following topics is suggested: Art, Science, and Technology, The Modern Self, Worlds of Fantasy and Imagination, and The Evocative Body. Like most categorizations, these are malleable, and there is much overlap between them, but they nevertheless provide a new scheme for thinking about the collection and the artistic and intellectual sinews that connect its different parts. Through them we can better understand modern sculpture's ability to illuminate what it has meant to be alive during the past 125 years, when so many drastic changes to ways of life and thought systems have taken hold.

Art, Science, and Technology

The revolutionary changes in sculpture during the early modern era must be attributed in part to purely formal concerns. One cannot separate, for example, Picasso's production of the first Cubist sculpture, his *Head (Fernande)* of 1909 (pl. 8), from his admiration of Paul Cézanne's flattened patches of painted form. Other forces also came into play, however, and no agent and symbol of modernity, in society and art alike, was more powerful than science, together with its handmaiden, technology. By the turn of the twentieth century, the industrial revolution had already brought far-reaching changes to virtually all aspects of modern life, and the pace of innovation was then only accelerating. Art was not immune to the excitement these changes inspired. The sculptor Raymond Duchamp-Villon, for example, lauded the powers of technology and machinery, noting in a letter in

magnificent skyspace *Tending*, (*Blue*), commissioned for the garden of the Nasher Sculpture Center (pl. 55).

Surveyed as a whole, the Nasher collection shows considerable balance between early modern works and art of the postwar era, abstraction and figuration, monumental outdoor and intimately scaled indoor works, and many of the different materials used in the production of modern art. Perhaps its single most distinguishing feature, however, is the depth with which it represents certain key artists, including Matisse (eleven sculptures), Picasso (seven), Smith (eight), Duchamp-Villon (seven), Moore (eight), Miró (four), and Giacometti (thirteen). Such well-rounded perspectives on the stylistic development of these masters provide in effect a series of mini-retrospectives within the collection's overall historical spectrum.

Parsed according to traditional stylistic and formal typologies, the collection presents a steady march of historical trends, from Cubism and Constructivism to Surrealism, different modes of expressive figuration, Minimalism, Pop, and to a lesser degree, Conceptual art and site-specific works. It is an interesting challenge, however, to analyze modern sculpture in general and the Nasher collection in particular through themes and issues different from these standard categories, which constitute a handy but highly imprecise tool. Great art creates different meanings for different generations, so relativity of viewpoint—and the different cultural and historical lenses that apply—are all-important. With that caveat understood, a wealth of key ideas can be traced through sculptural expression over the past 125 years. A history could be written, for example, based on materials and processes, tracking among other things the value systems attached to certain materials and the impact of new technologies and techniques on experimentation. The changing conditions of public and private patronage as well as the commercial art market are worthy of close scrutiny for their influence on the types of sculpture pro-

a disarming modesty and once noted, for example, that "We never thought of ourselves as collectors with a capital C—we just bought what pleased us."

Raymond is more apt to take a longer, historical view. He thinks about the collection as a totality, works to fill gaps and add to strengths, and tends to make up his mind more deliberately. They worked closely together as a team and fervently discussed possible additions with mutual respect for the other's opinion. Raymond has joked about the decision-making process that united husband and wife: "Yes, it was all very democratic. If we found something that I really liked, we would talk about it intensely for weeks. If we found something that Patsy liked, we bought it." Humor aside, however, Raymond sometimes had his personal favorites and built up the collection of works by Raymond Duchamp-Villon, for example, largely on his own (pl. 12, fig. 11).

Important to them both were the challenge and pleasure of siting three-dimensional objects and also the exciting interaction with living artists. Henry Moore, George Segal, Mark di Suvero, and Magdalena Abakanowicz, among many others, became friends. The Nashers shared reciprocal visits at home with Moore and bought works they first spotted in his studio. Several leading sculptors, such as Richard Serra and Richard Long, came to Dallas personally to install their works. The stone for Scott Burton's *Schist Furniture Group* (fig. 9) came from a quarry in Maryland that Patsy and the artist inspected together. The Nashers acquired di Suvero's *In the Bushes* at his studio in Petaluma, California, after the three of them had found the work sitting literally "in the bushes." And although they commissioned only a few site-specific works, they consulted closely on designs with Beverly Pepper for her *Dallas Land Canal*, installed in 1971 at NorthPark (fig. 12), and Raymond, during initial discussions with James Turrell, influenced the artist to think differently about the important interior lighting scheme in his

Art and accompanied by a thoroughly documented catalogue. Following its American presentation, the show toured to the Centro de Arte Reina Sofia in Madrid, the Forte di Belvedere in Florence (fig. 10), and the Tel Aviv Museum of Art. Patsy Nasher very sadly passed away after a long illness in 1988 just as the exhibition was to open at the Forte di Belvedere. A second large-scale exhibition of the collection, with a major catalogue, followed in 1996–97, organized by the Fine Arts Museums of San Francisco and the Solomon R. Guggenheim Museum in New York.

These exhibitions, with the scholarly apparatus of their catalogues and the worldwide attention they garnered, in many ways marked the coming of age of the collection. During the tours, the Nashers began to think about how they might make their remarkable holdings available to the public on a more regular basis. The educational nature of great art and its ability to enrich daily existence had been basic to their own attraction to these works and their program of sharing them through installations at NorthPark and loans to museums. Thoughts turned to the possibility of establishing, one day, the Nasher home and grounds as a museum. As counterproposals, entreaties came from different major museums for donation of the collection. In 1996–97 Raymond decided to fulfill their longtime mutual dream by personally financing in downtown Dallas the Nasher Sculpture Center and setting up a foundation to help ensure its permanence.

In important ways, Raymond and Patsy Nasher complemented one another as collectors. Patsy had an enthusiasm for modern art and an energy for its quest that were contagious. She was highly motivated, followed the market closely, did her art historical homework, but also relied on instinct and intuition. It was her perceptive eye for things new and important that drew many of the works by younger artists into the collection. She also had

Fig. 9 Scott Burton (American, 1939–1989)
Schist Furniture Group, 1983–84
Schist, settee and two chairs
approximately 43 x 28 x 32 in.
(109.2 x 71.1 x 81.3 cm.) overall

Fig. 10 Installation of Nasher Collection at
Forte di Belvedere, Florence, Italy, 1988
Courtesy of the Raymond and Patsy Nasher Collection,
Dallas, Texas

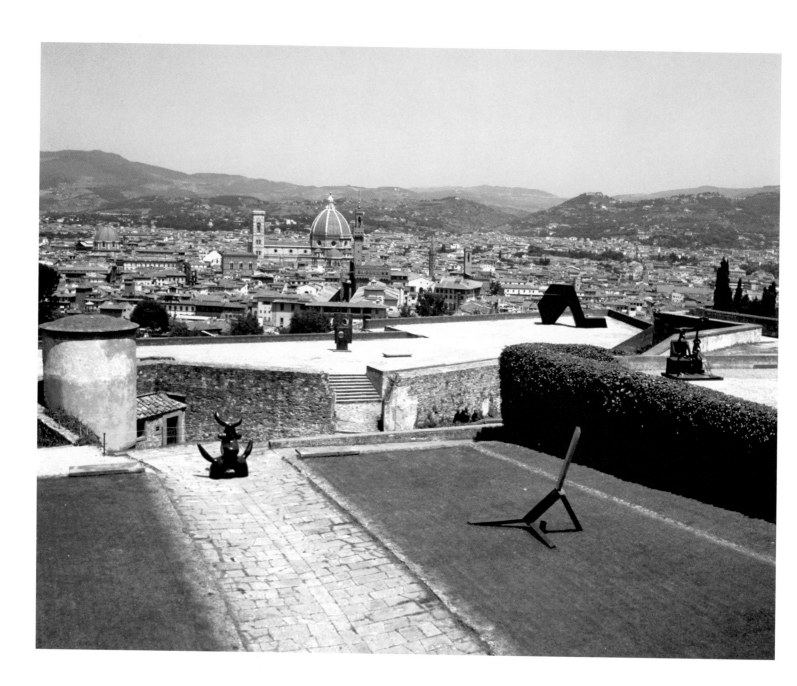

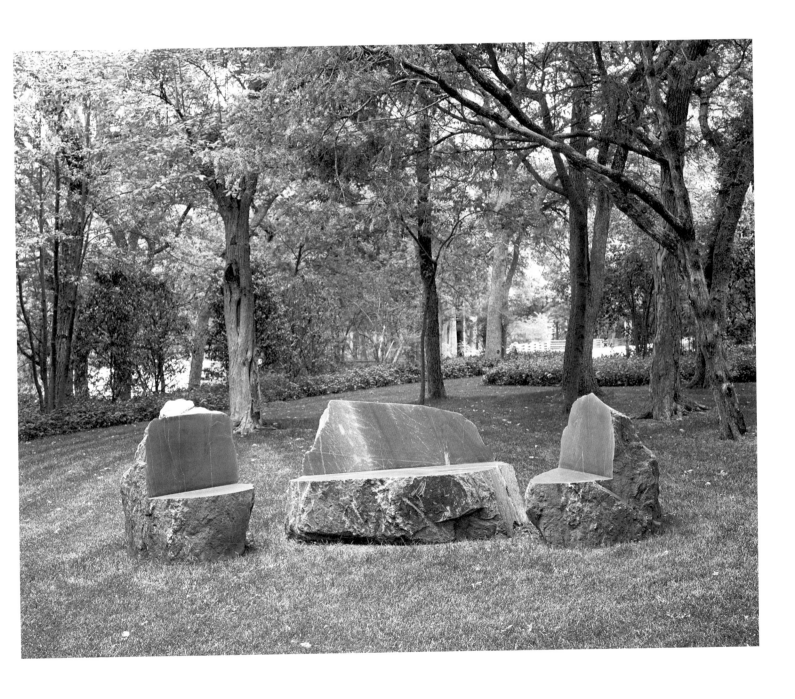

Fig. 6 NorthPark Shopping Center, Dallas, with installation of *Hammering Man* (1984–85) by Jonathan Borofsky

Fig. 7 Isamu Noguchi (American, 1904–1988) *Gregory* (*Effigy*), 1945 (cast 1969) Bronze, 69 1/4 x 16 1/8 x 16 3/8 in. (175.9 x 41 x 41.6 cm.)

Fig. 8 Claes Oldenburg (American, born Sweden, 1929) *Pile of Typewriter Erasers*, 1970–75 Acrylic on canvas filled with kapok, 7 x 28 x 22 in. (17.8 x 71.1 x 55.9 cm.) overall

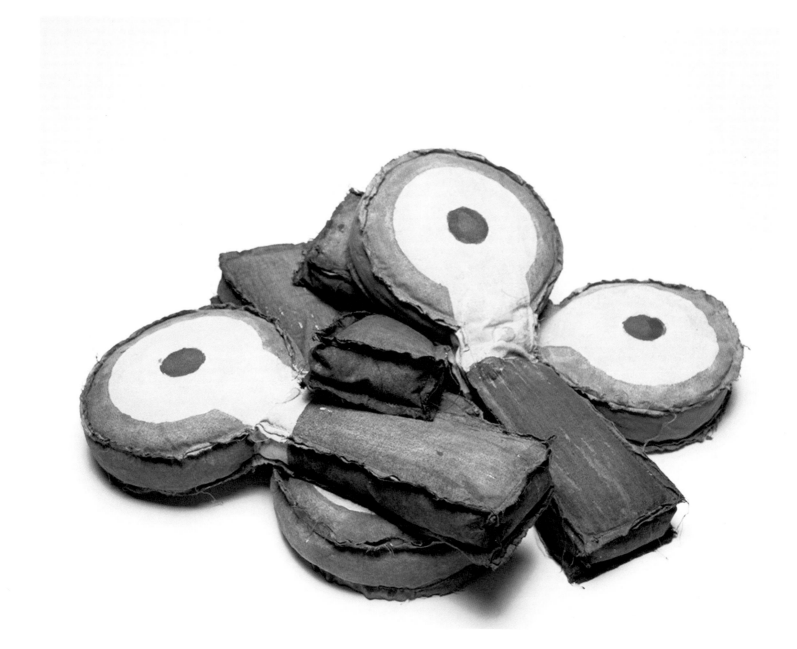

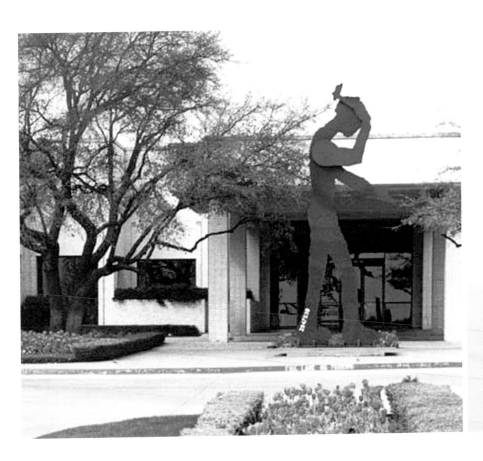

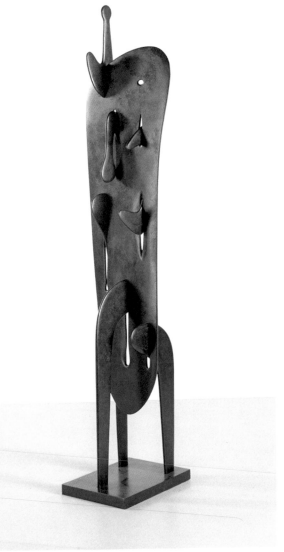

modern art: sculptures by major artists generally commanded much lower prices than paintings of comparable quality. With these factors at work, and with a home in North Dallas surrounded by beautiful wooded grounds that offered superb sites for outdoor installations, the Nashers began to indulge their passion for sculpture.

The Nashers had no particular game plan in mind when they began to collect, other than to buy only works that truly fascinated them. Early purchases tended to fall in the realm of classic modernism, such as Isamu Noguchi's *Gregory* (fig. 7), Calder's *Three Bollards* (pl. 20), and Joan Miró's *Moonbird* (pl. 22). It was not until the later 1970s that they began to look more seriously at contemporary art, and in so doing they displayed an eclectic and adventuresome taste that embraced diverse and sometimes challenging objects. Some of the first major acquisitions in this realm include Claes Oldenburg's *Pile of Typewriter Erasers* (fig. 8), Richard Serra's *Inverted House of Cards* (pl. 35), Donald Judd's *Untitled* (pl. 40), and Roy Lichtenstein's *Double Glass* (pl. 41). Works by younger artists such as Anish Kapoor, Richard Deacon, Jeff Koons, Scott Burton, and Martin Puryear soon followed (pls. 44, 46, fig. 9).

During the 1980s the collection grew at an accelerated pace. Outstanding works by virtually all the great masters of modern sculpture were added, including Henri Matisse, Picasso, Brancusi, Giacometti, Julio González, and Smith, frequently with not just one but numerous examples that capture an artist's stylistic development in crucially different phases. It became clear that a singular collection of modern sculpture was emerging, one that had few peers even among museums.

Recognition of this accomplishment led to a first touring exhibition, *A Century of Modern Sculpture: The Patsy and Raymond Nasher Collection*, organized in 1987–88 by the Dallas Museum of Art and the National Gallery of

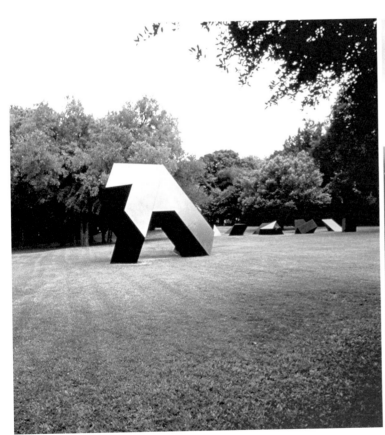

Morris, and Charles Sheeler. Travels to Mexico and archaeological sites piqued their interest in ancient Meso-America. They eventually amassed significant holdings of pre-Columbian art as well as Guatemalan textiles. The latter collection they donated to the Dallas Museum of Art.

Perhaps their interest in ancient stone carvings and ceramic objects also helped spark the Nashers' taste for modern sculpture. And as Raymond has often pointed out, his work as a builder made him attuned to the spatial strength of three-dimensional form. At any rate, by 1967–68 they had made their first significant purchases of modern sculpture, including the elegant *Torso with Buds* by Jean Arp (pl. 27), Barbara Hepworth's monumental *Squares with Two Circles* (pl. 30), and two imposing bronzes by Henry Moore, *Working Model for Three Piece No. 3: Vertebrae* (pl. 32) and *Two Piece Reclining Figure No. 9* (the latter no longer in the collection).

These works set a high standard for acquisitions to follow and excited them about the possibility of surrounding themselves with other great works. The notion that they might concentrate on sculpture also took hold at about this time. They had a natural proclivity for things three dimensional, and they enjoyed the challenges of installing sculptures at their home, both inside and out (figs. 4, 5). Raymond is fond of saying, for example, that "sculpture is much more interesting than painting, in that it is actually 360 different compositions as you walk around it, rather than just one," an observation that reminds us of David Smith's desire to pull multiple viewpoints into his works so they would become "an adventure viewed."[1] Raymond liked the idea that he might use sculptures to enliven spaces in his developments and eventually, for example, began to rotate groups of works through his highly successful NorthPark Center, a large indoor shopping complex in Dallas well known for its high degree of aesthetics in the buildings and grounds (fig. 6). The Nashers also recognized an anomaly in the market for

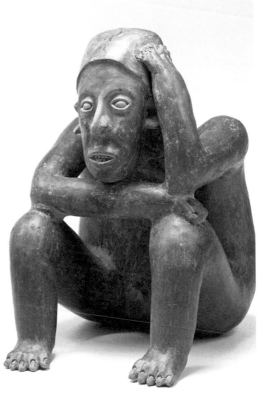

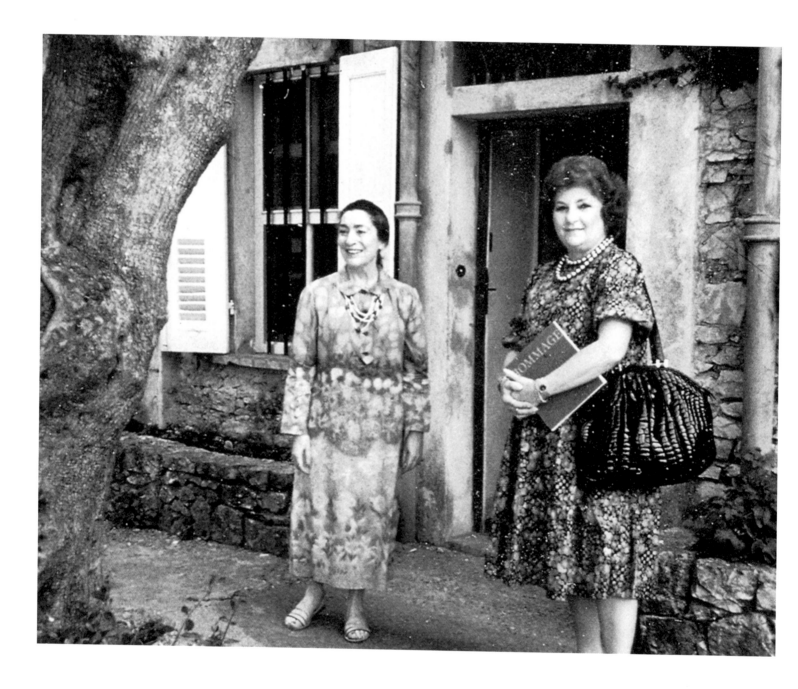

Fig. 1 Patsy Nasher with Jacqueline Picasso,
Mougins, July 1985

rethinking plastic form—its material being and expressive potential—that leads back to such pioneers as Auguste Rodin, Medardo Rosso, and Paul Gauguin. It is this tradition that the Nasher collection so richly chronicles.

As is often the case with major collections, the one formed by the Nashers started modestly, without ambitions of scale or encyclopedic reach. Their guiding principle for purchases from the beginning was simple: the works had to move them personally. Patsy was a born collector (fig. 1). Over the years she had put together large groups of objects as diverse as political buttons, Gypsy jewelry (which she later traded along with Navajo weavings to the equally acquisitive Andy Warhol in exchange for portraits of herself and the three Nasher daughters), and pre-Columbian jewelry. Raymond had been introduced to the joys of culture early in life by his immigrant parents. Living in Boston, the family would regularly visit area museums and attend lectures and concerts.

Patsy grew up in Dallas and attended Smith College, where she took courses in art history and majored in American studies. Raymond went to Duke University, served in the Navy toward the end of World War II, then attended graduate school in economics and urban development at Boston University. He saw opportunities in the building boom that hit the United States after the war and decided on a career in planning and development, eventually achieving great success in construction in both the residential and commercial fields. The Nashers were married in 1949 and moved in 1950 to Dallas, where Raymond set up his business with projects concentrated mainly in Florida and Texas, and where they raised their family.

Having long been interested in art, the Nashers began to buy works for their home, concentrating at first on American modernism and ancient and ethnographic art (figs. 2, 3). The prominent dealer Edith Halpert proved to be influential, and through her they purchased paintings by, among others, Stuart Davis, Ben Shahn, George L.K.

part for this discrepancy. There is also the old canard that sculpture's most basic condition, its three-dimensional physicality, is simultaneously its biggest detriment. Even Charles Baudelaire opined that sculpture's inert and literal solidity creates a confusion of viewpoints and, in contrast to painting, retards the medium's power of imaginative suggestion.

Modern sculptors, however, have proven time and again the flaws in this viewpoint. Far from playing second fiddle to painting's dominance, sculpture has enjoyed its own acts of visual invention and conceptual subversion, challenging the conventions by which art is made and stretching consciousness in new and exciting ways. One thinks immediately, for example, of Pablo Picasso's pasting a piece of rope around a painting, giving it three dimensionality, or his joining an actual absinthe spoon with a fictive bronze glass; Vladimir Tatlin's embrace of glass, steel, and wire as proud sculptural materials; Constantin Brancusi's polishing of shapes to a purity at once abstract and metaphorically rich; Alberto Giacometti's paring down of human anatomy to fragile yet somehow monumental stick figures; Alexander Calder's graceful balancing acts of form in space; David Smith's dialogue with light and reflection as the sculptural equals of solid form; and Carl Andre's assertion of the floor as sculpture's truest domain.

The vigor of these and so many other defiant gestures in the history of modern sculpture gives it a particularly willful quality, in which sculpture's basic tenets and forms are constantly under siege. In recent decades, this process of transformation and redefinition has gone so far as to raise fundamental questions about what sculpture really is. Cross linkages, for example, with video, performance, and installation art as well as with earthworks often leave us grasping for categories. Such transformations, however, are further steps in a long tradition of radically

The Nasher Sculpture Center, conceived as a serenely beautiful urban retreat for the enjoyment of modern art, is the new home of the renowned Raymond and Patsy Nasher collection of modern and contemporary sculpture. The collection—which numbers more than three hundred works together with twentieth-century paintings and drawings acquired by the Nashers—will be rotated in thematic installations through the Center's spacious garden created by Peter Walker and indoor galleries in the elegant, light-filled building designed by Renzo Piano. As many as eighty to ninety works will be on view at any one time. Special exhibitions drawn from other sources will also be presented, contributing to the Center's mission of examining as thoroughly as possible the primary forces shaping the history of sculpture since the late nineteenth century. The Nasher collection, however, will constitute the foundation of the Center's art program and its main focus. Through successive installations, audiences will gain a clearer understanding of its remarkable breadth as well as its deep strengths and the exciting ways that it connects the creative energy of those artists represented to our daily lives.

While no single collection can claim to trace in detail the complex artistic journey that constitutes the history of modern sculpture, the Nasher collection hits many of the high points of this tradition and also delves into some of its fascinating but lesser-known chapters. Artists are risk takers by nature and vocation, and sculpture over the past 125 years has embodied some of the boldest, most challenging, and creative initiatives seen in the entire history of Western art. It is an odd fact of our cultural times, however, that sculpture remains less well studied and less generally popular than its sister art of painting. The problems of photographing and illustrating sculpture effectively, the challenges for collectors of dealing with its maintenance and physical demands, and the fact that it does not partake of the pleasurable play of color and illusory space found in painting account at least in

The Nasher Collection: Celebrating Modern Sculpture
Steven A. Nash

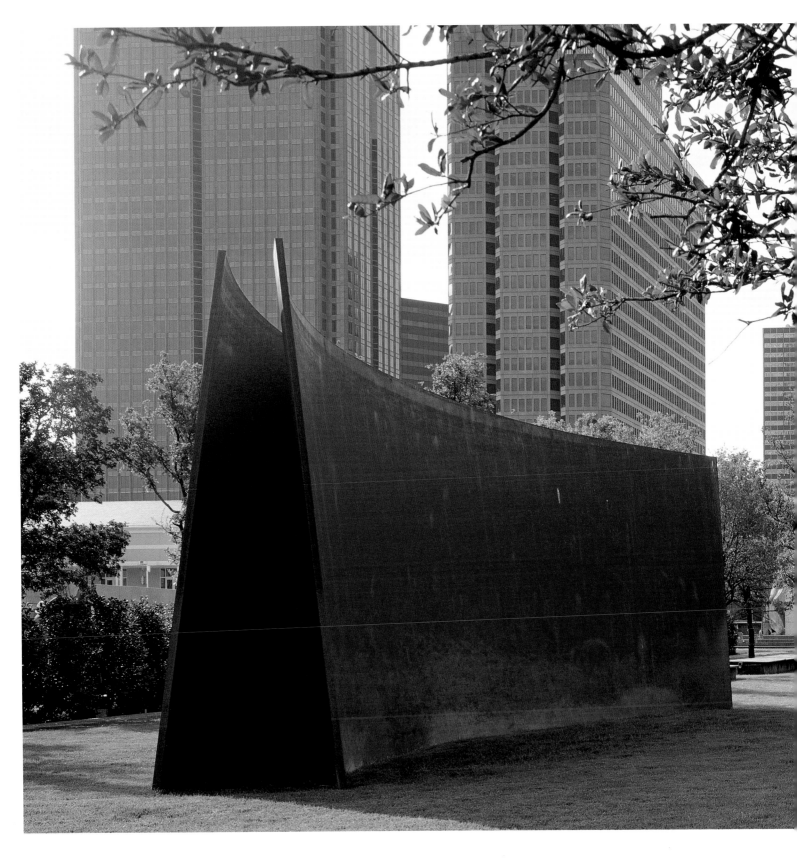

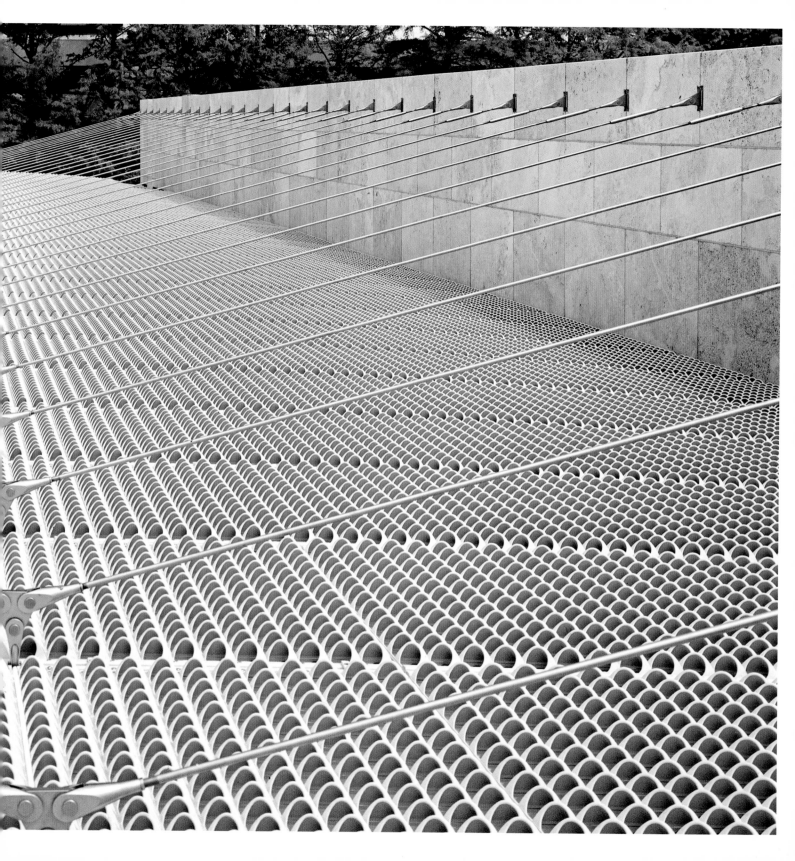

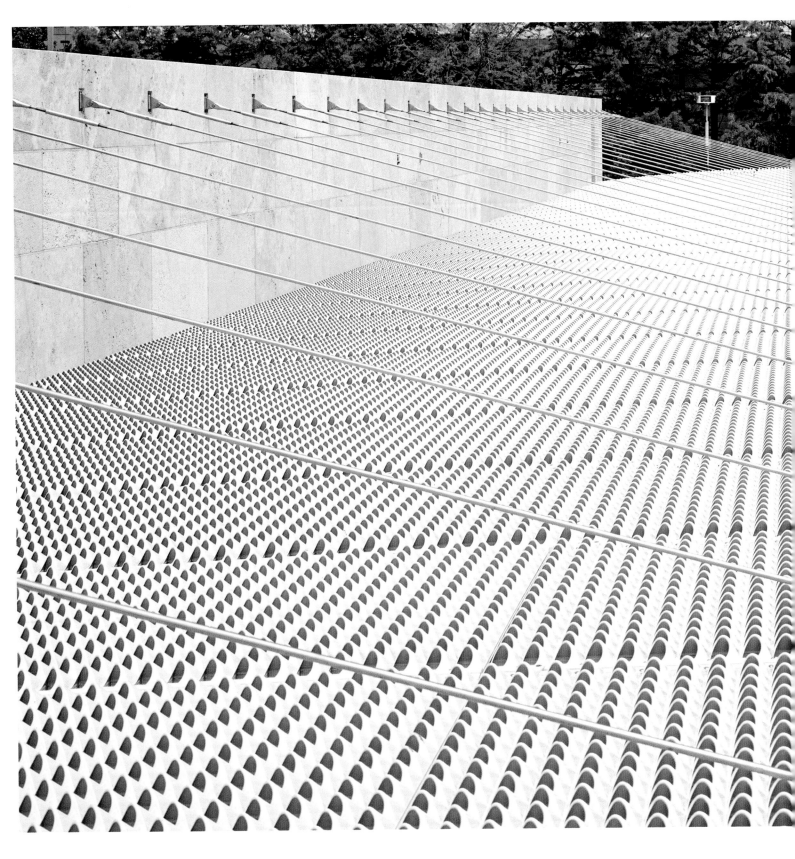

Construction of the Nasher Sculpture Center
photographs by Timothy Hursley

Notes

Unless indicated otherwise, quotations from Renzo Piano and Peter Walker are from a press conference held at the Dallas Museum of Art on June 5, 2000, and a public lecture by Walker at the University of North Texas, Denton, on November 15, 2000. Of great help in writing this essay were Peter Buchanan's four-volume study, *Renzo Piano Building Workshop* (London: Phaidon, 1993–2000), articles on the Nasher Sculpture Center by David Dillon appearing in the *Dallas Morning News* in 2000–02, and background information provided by Steven A. Nash, Director of the Nasher Sculpture Center.

1. Quoted in Carol Vogel, "Art Notes: Renzo Piano Revisits Texas," *New York Times*, August 6, 1999, E38.

2. Alan Riding, "Showcasing a Rise from Rebellion to Respectability," *New York Times*, March 5, 2000, Arts sec., 48; "Renzo Piano Speaks with RECORD about Skyscrapers and the City," *Architectural Record* 189 (October 2001): 137.

3. "Citation of the Jury," http://www.pritzkerprize.com/98piano.htm#Citation (accessed November 9, 2002).

In keeping with the vision of an urban cultural oasis shared as early as 1999 by Raymond Nasher and Renzo Piano, the Nasher Sculpture Center provides a new home for the Nasher collection that puts sculpture literally in the best possible light and creates transparency between inside and outside experiences. It manages to "steal" from the "mess" of the city a plot of land and to transform it into an artful site.

Plan of the final building and garden scheme,
2001—02 (prior to addition of site-specific work
by James Turrell at north end)

The wooden boardwalk remained, and some reeds were planted on the north side, but the arrangement here, as throughout the garden, is more geometric than in the earlier scheme. The lily pond adjacent to the café and terrace features thin, arcing streams of water projecting from jets sunk into the wall. Both this water treatment and that at the north end provide aesthetic pleasure, "visual refreshment," and help counteract noise from the outside. Walker's revised design, with its pared-down elements, offered a cleaner, more formal garden with affinities to the geometric forms of the building, while reinforcing and enhancing the visual and physical connectedness between galleries and garden.

With these modifications by Walker in the spring of 2002, the design of the Nasher Sculpture Center was effectively set. These were the last major adjustments to the plan, which had undergone significant alterations since the initial proposal of 1999. During the design process, the placement, size, and nature of the building had changed three times. The garden likewise experienced three major permutations. Despite the monumentality of its stone walls, the architecture maintains a comfortably human scale. The noble antiquity evoked by the travertine walls contrasts strikingly with the high-tech character of the web of steel rods holding in tension the glass canopy with its innovative sunscreen. The garden's formal and inherently public layout is countered by ample opportunities to stray from the paths for intimate moments of viewing and meditation. The collaboration between Renzo Piano and Peter Walker resulted in the creation of a splendid environment for viewing one of the great collections of modern and contemporary sculpture. The two architects accomplished the difficult feat of unifying a building that is itself a work of art with a garden that is also a major design accomplishment to produce an aesthetic and functional setting to highlight works of art of diverse forms, materials, and colors.

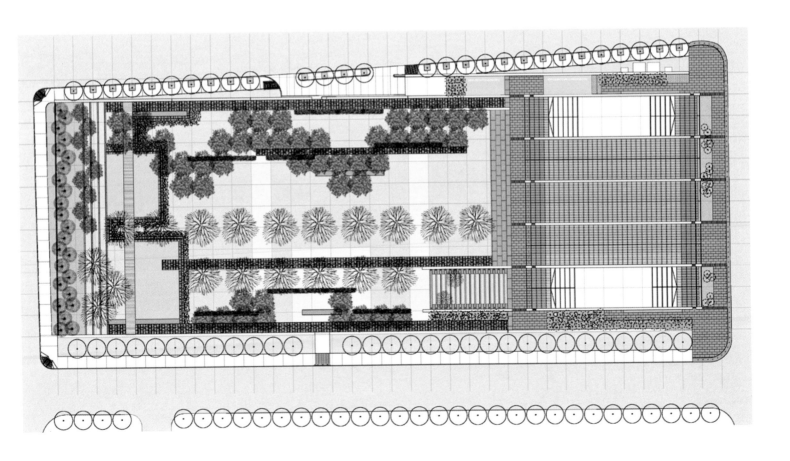

house to his private sculpture garden. Walker's design, referencing that garden, was meant to be, "not a complicated garden, but a series of complicated spaces."

On January 22, 2001, six months after the presentation of the Piano and Walker design, the Center's groundbreaking ceremony took place. Refinements and alterations to the design continued to be made well into 2002. In the spring of that year, the two architects unveiled their final version of the project. The building remained virtually the same, but the garden layout showed significant revision. While many of the individual elements, concepts, and experiences that Walker proposed earlier were retained, the spaces and plantings now followed a more rectilinear and minimalist arrangement. This revision reflected the architect's own long-standing modernist inclination. By paring down, Walker enhanced the quality of silence and meditation that he believes inherently occurs when design is reduced. The organization of the space evolved from a "gardenesque" to a linear and formal appearance. Rows and groups of trees aligned with, and metaphorically extended, the pavilions' walls. This new design produced both open spaces conducive to the installation of several large-scale sculptures and the flexibility required to rotate works in the collection on a regular schedule. More clearly than before, visitors are offered the option of following the green granite "Roman road" leading from the building down an allée of live oaks to the ponds, or the perimeter paths, or meandering across the grass. Gridlike configurations of hedges and cedar elms to either side create intimate viewing spaces and areas to be discovered while strolling. In this revised scheme, a small cubic, open-roofed structure—a site-specific work by the sculptor James Turrell— appeared at the north end of the garden. The wetlands at this end were transformed into two rectangular pools, across which runs a row of thirty-five bubbly water jets that can be adjusted to a maximum height of four feet.

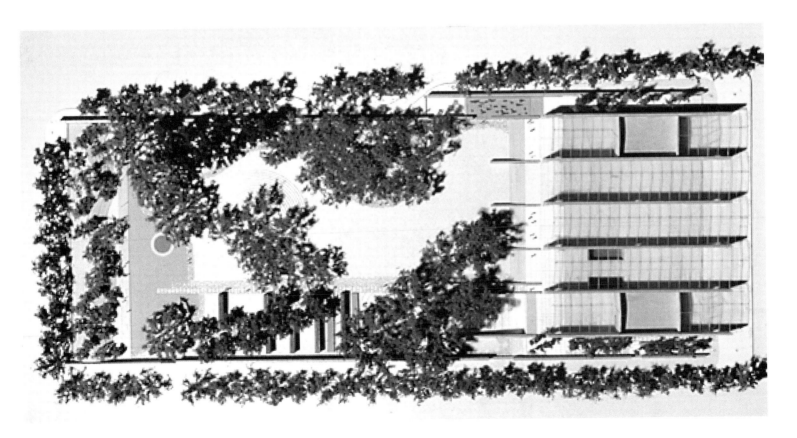

ment of the planting materials, a water element at the bottom (referencing the creek at the bottom of the Nasher residential property), and a straight green-granite-paved "little Roman road" that served as a path leading directly from the building to the back of the garden. Other paths "broke up" into the grass, so that people would be encouraged to walk anywhere. Walker has stated that the first job of any artist is to "place" the viewer. Here his space aimed to make visitors feel comfortable either following a path or striking out on their own. Another goal, related to exhibition flexibility, was to assure that superb locations were created to accommodate virtually any sculpture from the Nasher collection. The effort to avoid permanence extended to garden furniture, which Walker saw in terms of movable chairs, rather than fixed benches.

The garden plan included mounds and berms so that some sculptures would not be visible as one first entered the garden; this was done to pique visitors' curiosity and provide a sense of discovery. Walker has long embraced the notion that landscape design should generate a sense of mystery and offer places to explore. Through mounds and a variety of discrete spaces, he brought that sensibility to the Nasher Sculpture Center. Berms, particularly a major one at the north end, also act to muffle the sounds from the freeway and surrounding surface roads. At this same end appeared a pool of water treated like wetlands with rushes and various other water plants, with a boardwalk. Plant materials throughout were those familiarly seen in the Dallas area, including live oak, cedar elm, willow, and crape myrtle. Fescue grass, green year-round, was selected to lend a carpetlike feeling, and the soil technology of sports fields was imported to produce a surface that can sustain the wear of visitors, vagaries of weather, and the changing installation of sculpture. Water lilies appeared in another body of water: a small pond adjacent to the café along the terrace. The terrace itself resembled the steps from Nasher's

stressed in its archaeological references, sturdy travertine walls, symmetrical design, clear relationship of parts, and harmonious proportions (the 2:1 ratio of width to height in its bays, for example). The building's allusions to the ancient past place it outside modernist worship of the new for the sake of newness, while its elegantly restrained and beautifully proportioned forms differ greatly from often-cartoonish postmodernist pastiches of classicism. It suggests a timeless sanctuary set in the midst of the bustling, contemporary city, its low-slung profile contrasting dramatically with the high-rise buildings around it.

Despite these traditions and affinities, Renzo Piano's building design for the Nasher Sculpture Center is distinctively his own. He brilliantly realized his conception of a building that celebrates light and space. The stone walls relate to the physicality of sculpture, while what Piano describes as the "gossamer roof" allows the art objects to be viewed in optimal conditions of natural light. Most of the services and amenities of a larger museum are programmed into the design, but paramount in Piano's approach is the creation of a gracious and noncompetitive setting for art. The interior walls of smooth travertine, the ample and subtly proportioned galleries, the flexible combination of natural and artificial light from tracks in the roof beams—all create a pleasing environment for sculpture and paintings alike. With its airiness and transparency, the building embraces the surrounding landscape, stressing the unity between museum and garden, interior and exterior, art and nature, and promoting a flow between the two spheres. The garden is a constant point of reference.

Peter Walker's initial design for the green spaces around the building and the two-acre sculpture garden drew inspiration from the sculpture garden at Nasher's home. Walker wished to "recall the tranquility, domestic repose" of that space. His plan included curving paths (one circling a large sculpture), a picturesque arrange-

ting yet is also adjacent to a busy road. The Beyeler museum, particularly as viewed from the south, invokes the pavilion form with its long and open bays defined by porphyry and glass walls, over which floats a flat, cantilevered, glass-panel roof system employing photovoltaics and mechanized louvers to control light. The seeds for the design in Dallas lie in the elegant but unpretentious character of the Beyeler Foundation museum and the meeting between Renzo Piano and Raymond Nasher that occurred there. One other pavilion-like structure, not by Piano but known to him since his first days as a professional architect, undoubtedly affected his conception of the Nasher Sculpture Center.

Soon after receiving his architectural degree from Milan Polytechnic in 1964, Piano worked for a short period with Louis I. Kahn in Philadelphia. At the time, Kahn was beginning to design what many regard as his masterpiece and one of the twentieth century's great museum buildings, the Kimbell Art Museum (Fort Worth, 1972). Piano would have been exposed not only to Kahn's wrestling with the problem of relating a building consisting of long vaulted bays to a parklike setting but also to his efforts to control and incorporate in a stone interior the strong Texas light. The Kimbell, like the Nasher building, opens onto a garden on one side and addresses the street on the other. Given his experience with Kahn and the iconic status the Kimbell Art Museum has attained, it is easy to imagine that earlier building, only thirty-five miles from Dallas, echoing in Piano's mind as he designed the Nasher Sculpture Center.

Among Piano's many, diverse projects, the Nasher Sculpture Center stands out as the architect's most classicizing structure. Although the building, like all his work, features technological innovations, the Nasher Sculpture Center is unique in its commitment to fundamental classical values of balance, clarity, and order, a sensibility

Renzo Piano, Beyeler Foundation, Basel,
Switzerland, 1997

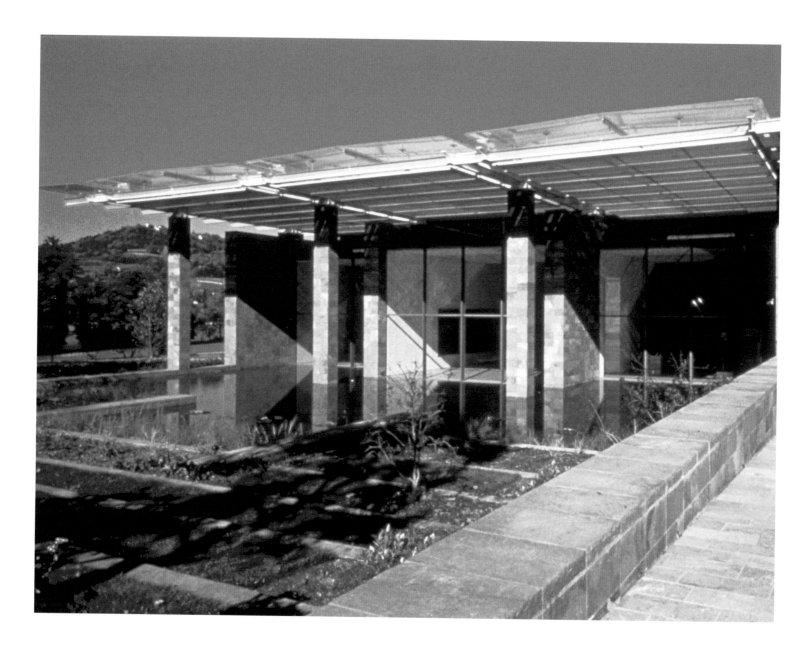

illumination than is permissible in a painting gallery, which results in conditions favorable for appreciating nuances of surface, texture, and form in the sculpture on view.

The use of pavilions strikes another, metaphorical note. By constructing long bays with strong, sculptural walls that extend beyond the glass roof to emphasize their "wall-ness," Piano reinforced his original concept of an archaeological site. This motif, however, also stimulates architectural associations with gardens and parks. Typically, garden pavilions are light and ornamented. Though defined by travertine walls, the Nasher Sculpture Center's bays achieve a similar airiness and spaciousness thanks to the pale color of the stone, the breadth of their interior spaces, and the glass canopy of a roof held in tension, spiderweb-like, by thin steel rods. Although the building is not ornamented in any traditional sense, the abutment of the walls' stone cladding and the intricacy and delicacy of the prestressed steel rods generate elegant, subtle patterns. The high-tech look of this steel support system, custom-fabricated in Italy, suggests yet another reference: the pavilion as a flexible and striking exposition structure, as seen, for example, in the one that Piano designed for IBM in 1984 to travel to several sites in Europe.

The recurrence of the pavilion as a dominant architectural typology in Piano's work is further evidenced by the structure of his own studio, the Renzo Piano Building Workshop (Genoa, 1991), and also the Beyeler Foundation museum (1997) in Riehen, a suburb of Basel, Switzerland. The latter building merits special attention within the contextual history of the Nasher Sculpture Center. It was at the Beyeler's opening that Raymond Nasher, a great admirer of Piano's Menil Collection in Houston, had the opportunity to meet the architect, who gave him a private tour of the Beyeler. This building, also designed to house a privately owned collection, occupies a park set-

Renzo Piano, sketch of a vaulted sunscreen over a vaulted roof, 2000

Renzo Piano, sketch of a catenary sunscreen over a flat roof, 2000

Test of an early model for the sunscreen, 2000

Drawing for the connector unit for the tension rods

View from inside a gallery looking due north through the sunscreen

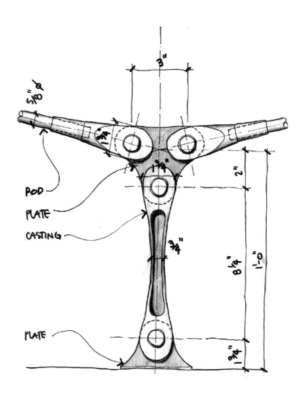

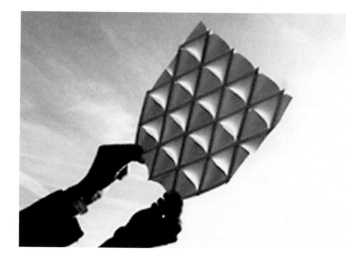

All the pavilions feature full-length glass walls at each end. The three central pavilions allow unobstructed views from end to end, so that passersby—whether in vehicles or on foot—can gaze into the building to see sculpture in its galleries and glimpse the garden with its art in the distance. The pavilions become visual chutes connecting the outside world with the contents of the buildings and the garden. This concept of linking the city, the interior galleries of the building, and the sculpture garden assumed prominence in this final stage of the building's design. The transparency from street to garden absorbs visitors into the Center even before they actually enter it and promotes the concept of building and garden as a coherent, interconnected unity. Inside the building, all five pavilions have glass walls onto the garden, so that people moving from interior to exterior experience a nearly seamless sense of visual continuity. To reinforce this sensibility, Piano extended the walls of the pavilions fourteen feet beyond their glass membrane onto the terrace that leads to the garden's steps. Opening a door to the terrace, then, puts the visitor into a liminal or threshold area: simultaneously outside the gallery, still under its roof, and on the edge of the garden. One space slips into another.

To ensure the most luminous effects possible within the building, Piano used a special glass whose low-iron composition makes the glazing remarkably clear. The architect regards the glass roof as a thin membrane, skin-like, which permits a dappling effect and the "percolation" of natural light. Facilitating this percolation is his specially designed sunscreen and weather shield, which took a year and a half to develop and fabricate. Resembling an inverted egg carton, the cast-aluminum screen—consisting of four-by-four-foot sections, each with 270 nodules or hoods—floats over the glass roof. The opening of each form faces due north and scoops in that most consistent light, while blocking out all direct sunlight. From inside the galleries, the sunscreen suggests latticework, but when the visitor faces north, the screen virtually disappears. This system allows a higher level of

Cross sections through the garden and building showing the terraced garden steps connecting on lower level to the indoor auditorium

Floor plan of upper level of the Nasher Sculpture Center

Floor plan of lower level of the Nasher Sculpture Center

View of building model from front through galleries to the garden

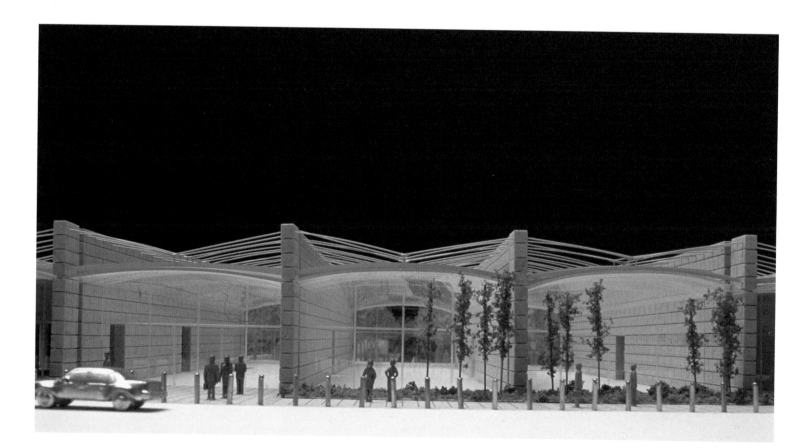

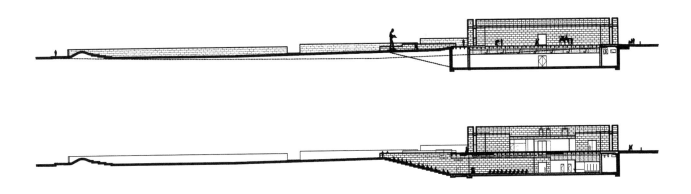

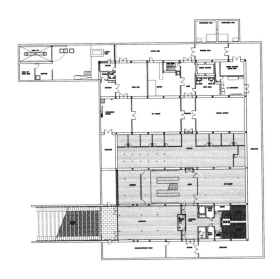

Detail of roof showing sunscreen and
tension rods

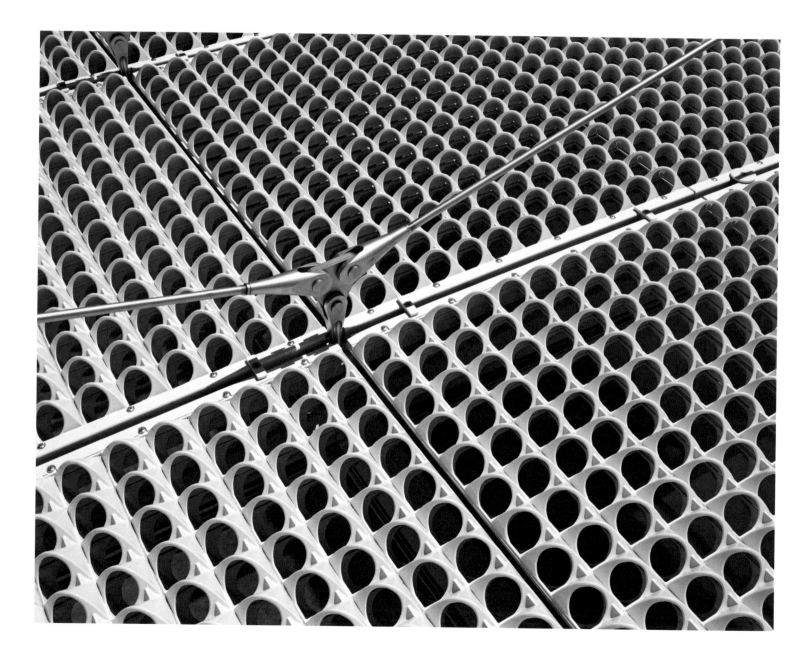

ture was substantially larger than either of the two earlier plans. Between the second and this third plan, it was decided to increase the interior gallery space from 4,000 to approximately 10,000 square feet. This would allow the display of a larger number of smaller, indoor sculptures and other works from the collection. Each pavilion measures 16 feet high by 32 feet wide by 112 feet long. The pavilions are covered by a vaulted roof consisting of slightly arched steel beams and curved panels of glass. Piano had developed by this time, at Nasher's urging, an innovative aluminum sunscreen to protect the glass and control the amount and directional spread of natural light penetrating the roof. These sunscreens follow the arch of the glass, with the whole structure connected to the walls by a network of steel tension rods. Piano worked for a long time on perfecting the exact curve of the arches, finally deciding on a one-foot rise from the sides to the middle, a subtle gesture that adds a gentle wave-like motion to the facades.

The three central pavilions in this new plan function as an entrance bay and galleries for smaller and environmentally sensitive sculptures from the Nasher collection. The two pavilions at each end house the director's office, boardroom, bookshop, multipurpose room, and a café. On the lower level is a gallery for light-sensitive works, such as drawings and prints, as well as facilities for education, research, conservation, storage, delivery, and public programs. The area for the latter is unusual in that instead of taking the typical form of an auditorium, it is an open, flexible space with a flat floor and a floor-to-ceiling glass wall facing a small amphitheater outside. This wall can be completely retracted, so that visitors may be seated both indoors and outdoors during a musical performance, for example. Also unusual is the solution to the service-delivery area. Because of limited space, a system was devised that allows a truck to pull off Olive Street, back onto a lift, and be lowered to the loading dock, thus eliminating any "back door" on the ground level.

Symphony Hall a few blocks to the east along Flora Street. Although other facilities were constructed or rede-
signed to be part of the Arts District, the ambitious vision of the project languished during the 1990s. By fronting
the Nasher Sculpture Center on Flora Street, the two architects intended to offer the building as a dynamic
boost to the revival of the Arts District and to revitalize the significance of Flora Street as a major art corridor.
In fact, the impact of the Nasher Sculpture Center's presence sparked renewed interest in the Arts District well
before its opening: at the end of 2001 Norman Foster and Rem Koolhaas had been selected to design two the-
aters for the Dallas Center for the Performing Arts.

Piano designed the Center's building so that it achieved the architects' desire to engage the life of the street.
An active relationship between the profane (the street) and the sacred (the Center) had informed Piano's think-
ing from the beginning. Early on, Nasher argued for closing Harwood Street, but Piano lobbied against this
notion. He wanted the Center to be woven into the fabric of the city and form part of its rich tapestry of the ordi-
nary and the extraordinary. Piano imagined the garden, not as a paradise on Earth, but as a place enriched by
the turmoil of the city. It, in turn, would reinvigorate the city. To open the garden to the city, and vice versa, Piano
punctured the protective travertine walls on the west and east edges to produce a number of openings. Here he
also realized his initial conceit of ancient, preexisting walls, by having the Tuscan-quarried stone blasted by
high-pressure water jets, to reveal what Piano calls the stone's "vibrating" texture and to roughen its surface to
simulate weathering and age.

In this mid-2000 plan, five parallel, connected pavilions, each defined by side walls clad in smooth travertine and
topped by a vaulted glass roof, constitute the main street level of the building. At 55,000 square feet, the struc-

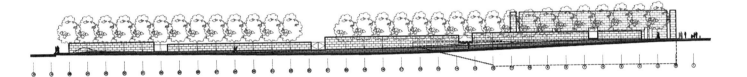

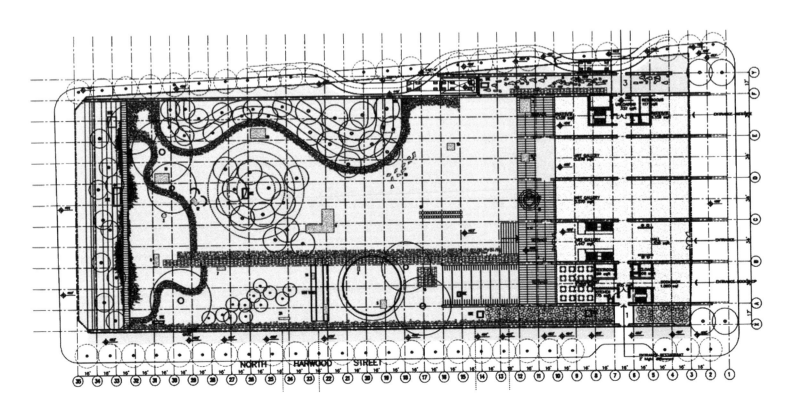

ed visitors with a continuous natural canopy of relief from the Texas sun. With the second plan's shifting the building to one end, the garden's configuration and its relationship to the building changed significantly. In recognition of the garden's fundamental importance in the overall project and its altered configuration in this revised plan, a new conception of the garden's design was needed. Consequently, it was decided to bring in a landscape architect who would focus on creating an aesthetically pleasing garden that would function effectively as an outdoor sculpture museum. A specialist was needed, one whose expertise included knowledge of appropriate regional plantings as well as the technologies of irrigation and drainage systems. Chosen to fulfill this crucial role was the esteemed landscape designer Peter Walker. Internationally recognized, Walker, principal of the California-based firm Peter Walker and Partners, was already familiar with the north-central Texas environment from his designs for Burnett Park in Fort Worth (1983) and the Solana corporate office complex and park in Westlake and Southlake, northwest of Dallas (1991). Although Walker and Piano had separate design responsibilities, each knew that the success of the overall project centered on their combined ability to produce a unified, coherent design.

On June 5, 2000, the results of the Piano-Walker collaboration were publicly unveiled. A larger building, consisting of five slender pavilions, now occupied the south end of the lot and faced Flora Street. The change in location, which had been discussed in design meetings in November 1999, was owed in large part to Piano and Walker's perception that Flora Street, an integral artery running through the Dallas Arts District, could become a "festival street." A civic arts district began to be developed in 1984 with the opening of the Dallas Museum of Art, which had relocated from Fair Park to downtown. The presence of the Edward Larrabee Barnes- designed building, anchoring Flora Street on the west, helped generate the location of I. M. Pei's Morton H. Meyerson

flow of traffic between them awkward. Also, Nasher was dissatisfied with the type of louvered roof that Piano first proposed for the building. He made the point that similar roofs had already been used in earlier Piano buildings, and what the Center needed was something entirely different. These considerations led to the drafting of a second design.

Before the next scheme was developed, the decision was made to move the building to the north end of the site. Thus Piano's second design, completed in November 1999, shows the building situated to the north. The service entrance, greatly shortened, remained in place. The parking garage entry, however, was eliminated, as that facility was dropped from the project. Piano maintained the visitor entrance on Harwood Street but now oriented it to a constantly used driveway access to the art museum across the street. The advantages of the new plan included this more public entrance and a more open garden space unencumbered by the presence of the building. Further, the placement of the building—still defined by stone walls and a lightweight roof—would offer a spectacular view of downtown, while serving to buffer noise from the nearby Woodall Rogers Freeway. The proximity to the freeway was admittedly a disadvantage, for it meant that the visitor entrance would be enveloped in the noise and commotion of the highway and its service road. Another concern involved the garden's slight upward slope to the south. Walking up, rather than down, subtly undermined the metaphor of an archaeological zone. Entering the garden from the north also meant that the visitors would frequently have to contend with the sun in their eyes and initially see most of the sculpture illuminated from behind.

Although the first design had indicated a landscape treatment for the garden, the plans for the second design did not. Piano's first idea had featured substantial shade trees along the garden's perimeter, which would have provid-

Ancient ruins in Herdonia, Italy

Plan of the first building and garden scheme, 1999

Plan of the second building scheme, 1999

Model of walls for first building scheme, 1999

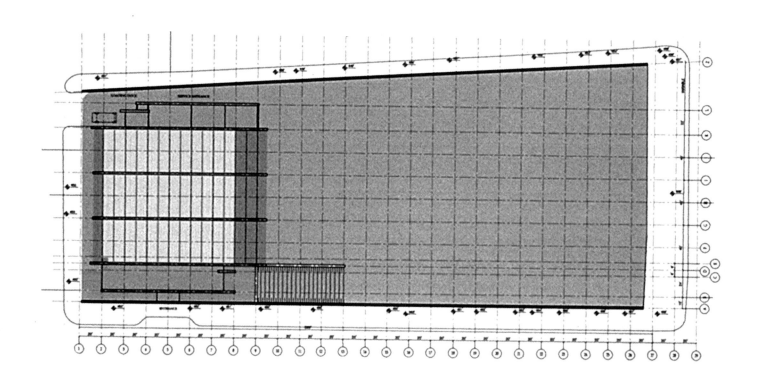

slightly excavated garden on its longer east-west edges (Olive and Harwood Streets), with natural berms on the shorter north-south ends (Woodall Rogers Freeway Service Road and Flora Street). Between the three walls on the west side, the architect envisioned a hanging, lightweight glass-roof structure that would allow natural light into the galleries and other facilities enclosed by the walls. Along the east flank, another, different configuration of three walls defined a service access (from the north) and an underground parking entrance off Olive Street. The Center's entrance fronted Harwood Street and was aligned axially with the Fleischner Courtyard of the Dallas Museum of Art.

Besides framing service and gallery areas, and demarcating and protecting the garden, the walls were conceptually and metaphorically important to Piano in signaling the contrast to the surrounding city. The walls imbued the site with an archaeological ambience. Characterizing the walls as the "topology of the place," Piano saw them as "preexisting," as though they were the remnants of an ancient building or temple, a noble ruin extant in the middle of the busy downtown. This allusion to the past reinforced the Nasher as a special site, distinct from the surrounding shiny newness of the Dallas urban environment.

This initial plan of mid-1999, however, had two drawbacks. First, siting the building longitudinally meant that it cut into the width of the garden. Given that the plot was nearly three times as long as it was wide, any loss in garden width would reduce the options available for installing sculpture. In addition, for visitors walking from one end of the garden to the other, the building would be a visible "companion" shadowing them for two-thirds of their walk. The second drawback involved the building's axial relationship to the Dallas Museum of Art. The entrance to the Nasher Sculpture Center was aligned with a museum entrance that was rarely used, making the

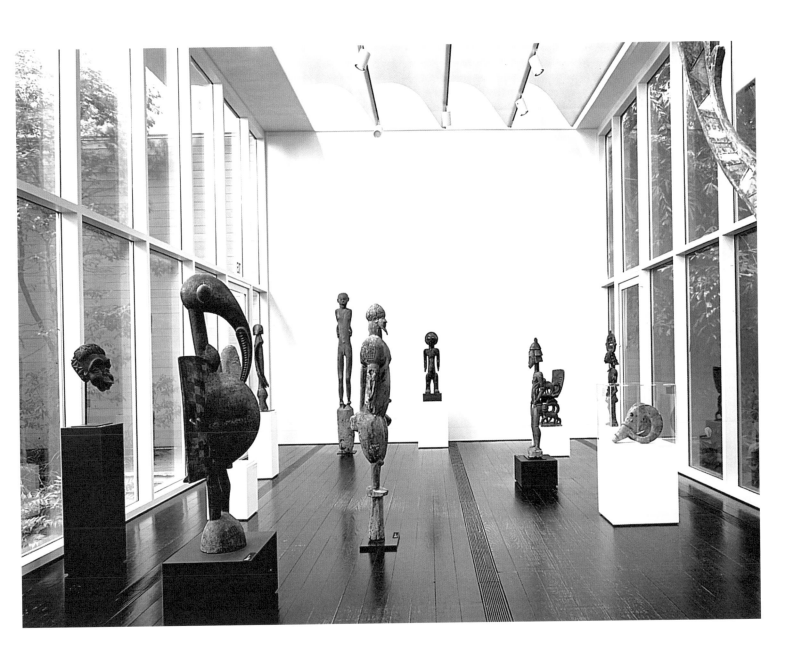

struction itself is underscored by the name he selected for his architectural firm—Renzo Piano Building Workshop. His avoidance of stylistic dogma and his desire for a project's own integrity were noted by the jury for the Pritzker Architecture Prize (the "Nobel Prize" for architecture), which Piano received in 1998: "The array of buildings by Renzo Piano is staggering in scope and comprehensive in the diversity of scale, material and form." [3] Distinctiveness and appropriateness, not a set manner, mark the character and success of Piano's buildings, from the urbane high-tech bravado of the Centre Georges Pompidou to the residential contextual integration of the Menil Collection (Houston, 1986), to the elegantly swooping curves of the mile-long Kansai International Airport Terminal (Bay of Osaka, 1994), to the exquisite refinement and flexibility of the Nasher Sculpture Center.

In considering how to provide the spaces the Nasher Sculpture Center needed for its ongoing program of rotating sculptural installations, Piano conceived of the sculpture garden, not as a fixed, static space, but as a "roofless museum" with changing works of art. He visualized the Center as an open-air museum rather than a traditional sculpture garden. Another nontraditional quality, which captivated the architect, was the project's location: Piano amiably regards the site as being in the "mess" of the city. Embedded in the urban fabric, the location differs from pastoral locales often associated with sculpture gardens. The situation struck him as challenging and provocative; he was being offered the opportunity "to steal this piece of land from its normal destiny." The plot of land's "normal destiny," at the time of the project's conception, was being fulfilled as a city block-sized parking lot. To subvert the order of things and transform the site into a place of serenity and contemplation in the midst of urban commotion became a central motivating factor in Piano's thinking about the design of the Center.

To define the new space, Piano initially conceived of a series of low, parallel, fragmented stone walls flanking the

be "poetic and very exciting,"[1] and he felt Piano best understood one of the qualities Nasher saw as fundamental to the Center: flexibility, to facilitate changing installations of sculpture and adjust to growth in the collection. The range and diversity of Piano's building designs and concepts testified to his ability to meet this prerequisite.

Although Renzo Piano will forever be associated with the high-tech style of the Centre Georges Pompidou in Paris, his buildings cannot be pinned down to a single idiom. Even the Pompidou, which he designed in partnership with Richard Rogers after winning an international competition in 1971, was not for Piano strictly speaking "high tech," despite its exoskeletal structure of colorfully painted ducts and pipes and its resemblance to, in the architect's own words, a spaceship. Rather than characterizing it as high tech, Piano describes the Pompidou as a double provocation: a challenge to academicism and a parody of technological modernism. As a building of complexity and contradiction, this structure, which was completed in 1978, can plausibly be called the first postmodernist building. Piano makes no such claim, and his work, in fact, has consistently eluded stylistic labeling.

"Style," for Piano, signifies both a narcissistic attitude and a dangerous concept, because "you end up imposing your stamp before you understand what is the reality of a place."[2] More important for him is the sense of a building's coherence. An architect's preferences may be recognizable—an emphasis on lightweight construction, transparency, and natural light, in Piano's case—but they cohere differently in each building because each site, client, and purpose differ and offer new opportunities for architectural exploration. The architect is guided by the principle that every building has and tells its own distinct story. Much of Piano's opposition to the arrogance of style is grounded in the practicalities of his family's background: his grandfather, father, and older brother were all builders, and he himself worked for a while in the family business. His commitment to the practice of con-

Aerial view of downtown Dallas with the site
of the Nasher Sculpture Center indicated in white

Renzo Piano and Raymond Nasher viewing a
mock-up of a section of a gallery in Turin, Italy,
March 2001

The Nasher Sculpture Center is not only a collection of works of art; it is a work of art in itself. Like the sculpture collection it houses, the Center's design is the result of a carefully considered process of development and refinement. Between 1999 and 2002 three substantially different plans were proposed before a design was devised that, aesthetically and functionally, best suited the collection, the client, the viewer, and the site. Numerous planning sessions in Genoa and Dallas between the Center's founder, Raymond Nasher, and its architect, Renzo Piano, with their respective project teams, were part of the close client-designer relationship that fueled this evolution.

The Nasher Sculpture Center occupies a 2.4-acre site in downtown Dallas, a city block bounded by Flora Street on the south, Harwood Street on the west, the Woodall Rogers Freeway Service Road on the north, and Olive Street on the east. Olive Street runs at a slight angle, so the Center's narrow lot is slightly wider at its south edge than at its north. The ground slopes upward to the south, at about a 2 percent grade. To the immediate west of the site rises the monumental modernist building of the Dallas Museum of Art, designed by Edward Larrabee Barnes (1984). Two blocks east of the Center is I. M. Pei's grand Morton H. Meyerson Symphony Hall (1989). The Nasher Sculpture Center thus forms an integral part of what has been designated the Dallas Arts District.

Originally, Raymond Nasher conceived of a sculpture garden with a small pavilion gallery within it. However, even before the first designs were drafted, the project had expanded to include a larger building that would house galleries, offices, a shop, a café, and an auditorium. The crucial initial step in the design process, that of selecting an architect, occurred over a two-year period. After speaking with numerous architects, Nasher concluded in mid-1999 that Renzo Piano would be the best choice. Nasher found the Italian architect's ideas to

The Art of Designing the Nasher Sculpture Center
Mark Thistlethwaite

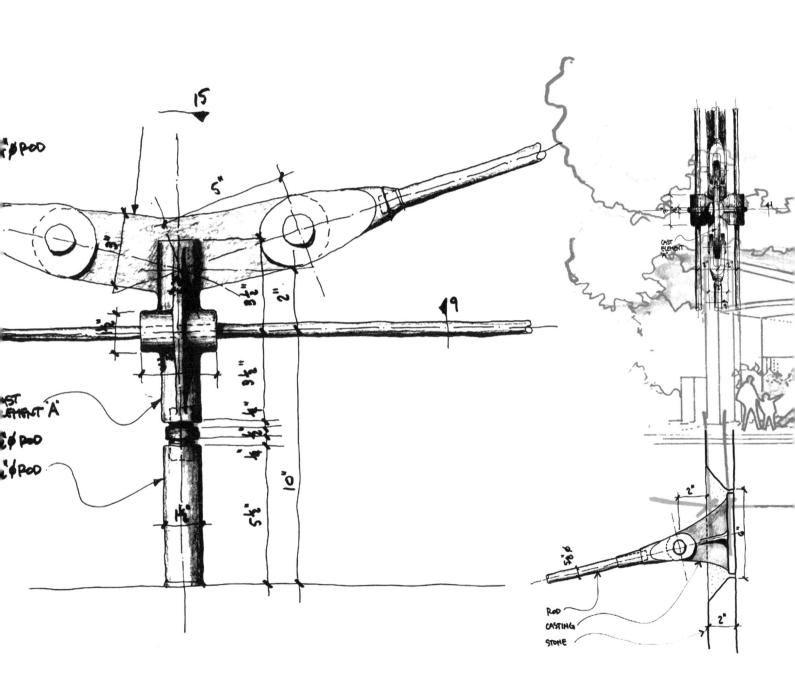

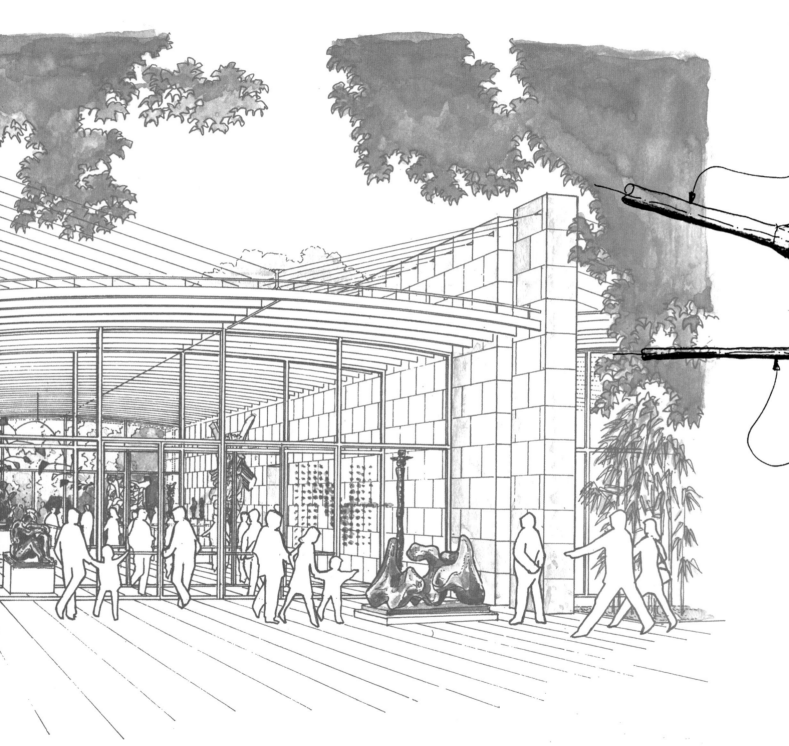

t from roof (only with light).

the MASTER
FOURTH
Dulls
JRW 2002

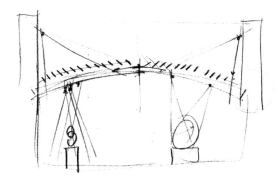

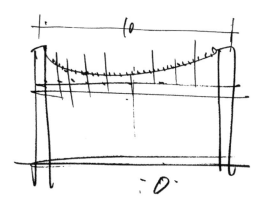

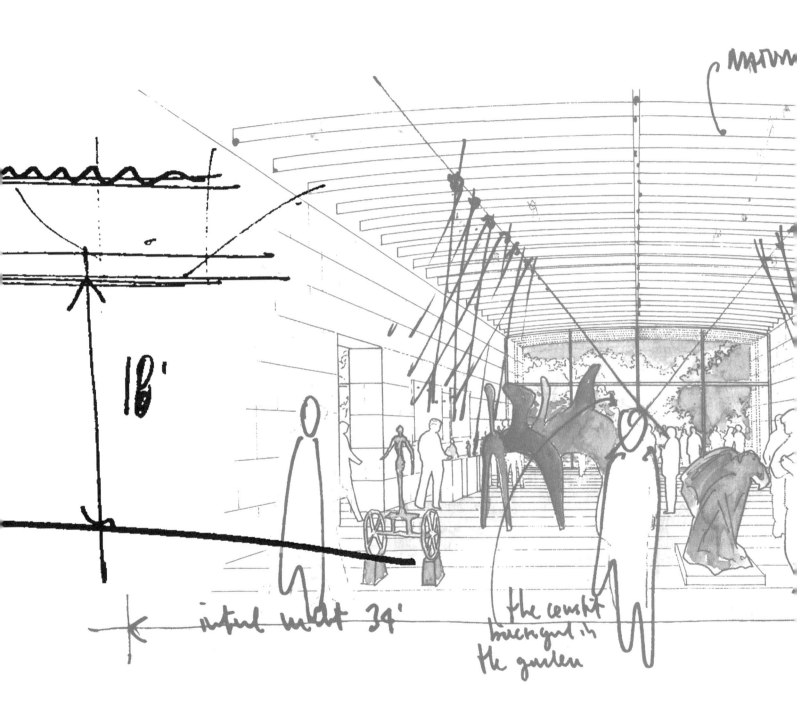

natur

18'

intnl volt 39'

the censtit bucnigud is the gurden

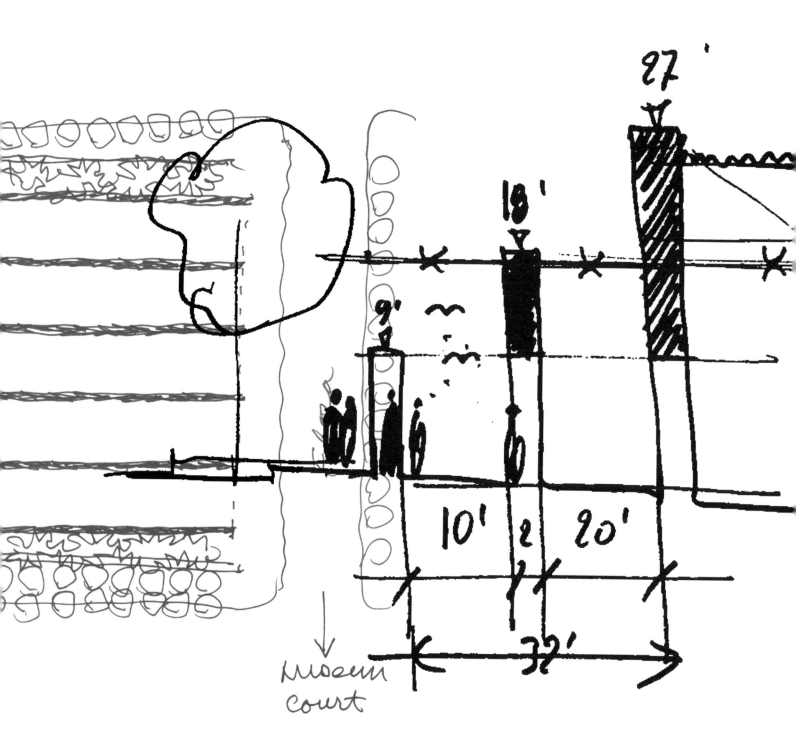

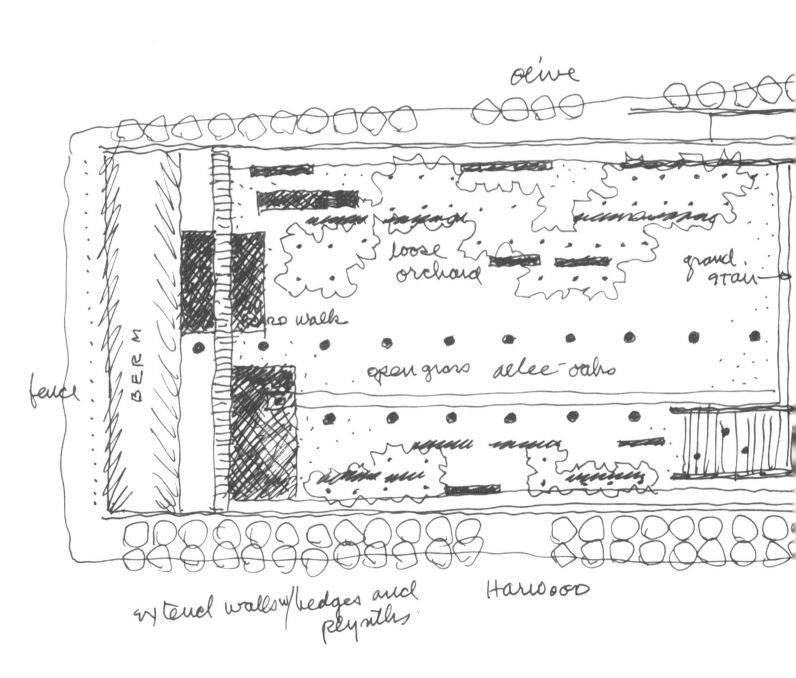

olive

loose orchard

grand grain

no walk

BERM

fence

open grass allee-oaks

extend walls w/ hedges and plynths

Hardwood

Renzo Piano Building Workshop (RPBW)
Perspective view from lower end of garden
at pools, 2002

Peter Walker
Sketch for sculpture garden space concept

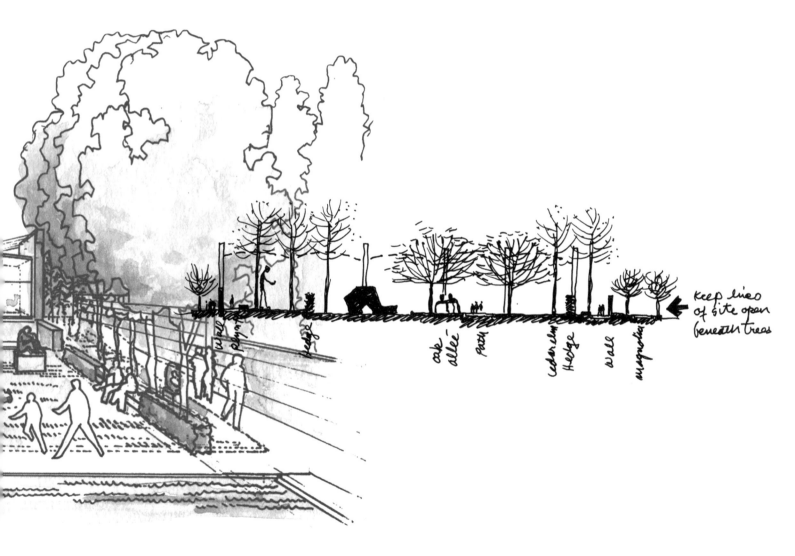

keep lines
of site open
beneath trees

wall
Plane

hedge

oak
allee

path

cedar elm
Hedge

wall

magnolia

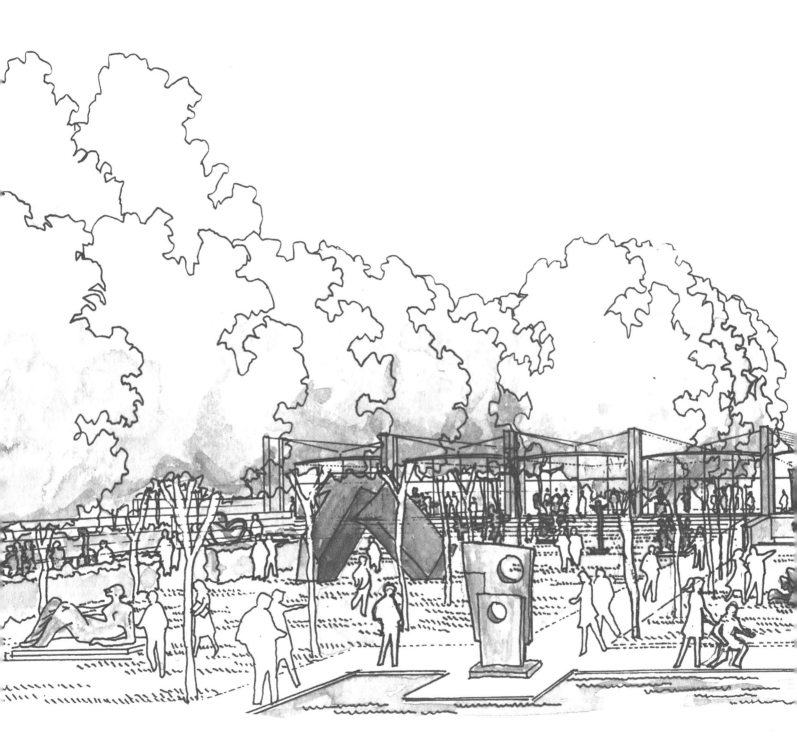

Renzo Piano
Early sketch of facade of building showing walls and concave sunscreens, 2000

Renzo Piano
Concept sketches showing site with different placements of the building, 1999–2000

Renzo Piano
Sketch of building from Flora Street, with vaulted ceilings and overhanging canopy of trees, 2000

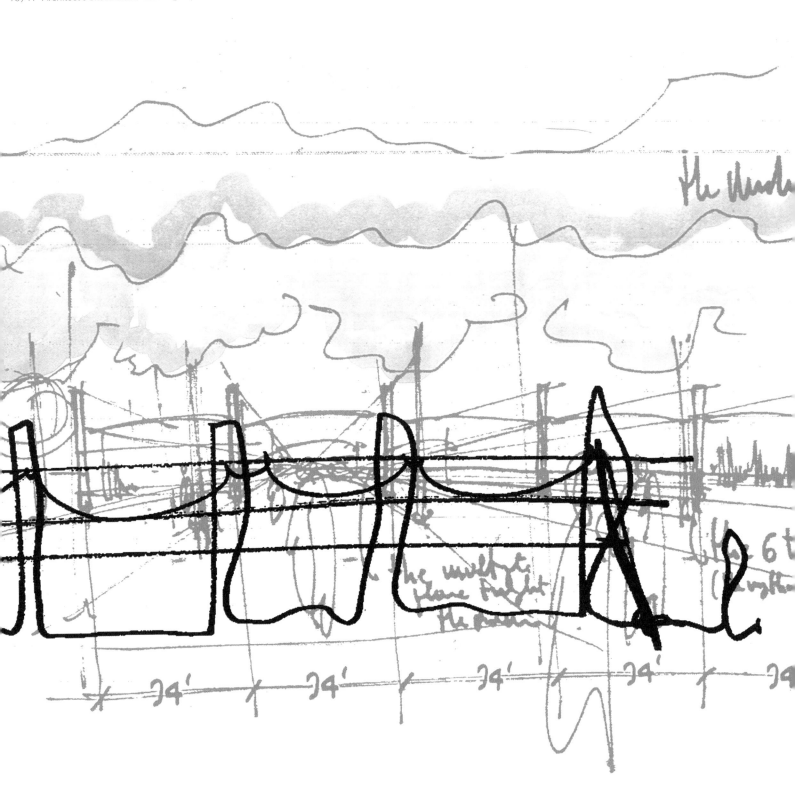

Architect's Sketchbook

Drawings by Renzo Piano, RPBW, and Peter Walker

The lower level houses an auditorium that seats two hundred for lectures, seminars, films, and musical events, and can be opened to an outdoor stepped terrace for presentation of different kinds of programs "in the round," as weather permits. It also includes another exhibition gallery, an education classroom, office and research space, and, behind the scenes, a sculpture conservation studio, art storage, a catering kitchen, a loading dock, and space for all the mechanical and air-conditioning equipment.

The garden, which Renzo Piano calls the "museum without a roof," is a refreshing and inviting travertine-walled park with trees (more than 170 in number), hedges, fountains, stone paths, and grass that is green all year round and drains rapidly after even the most dramatic Texas rainstorm—all designed to create varied environments for the display of outdoor sculpture. Lightweight, movable chairs will allow visitors to sit wherever they want to rest and observe art and nature. Outdoor installations will be rotated once a year.

At the far end of the garden is a commissioned work by the artist James Turrell—a freestanding structure containing a light installation and an open skyspace for viewing the sky, with optical effects changing as the natural light varies during the course of the day and early evening. The structure contains seating for twenty people and will be heated in winter and air-conditioned in summer.

In summary, our intent was to create an urban cultural retreat surrounded by the energy of the large city but offering a serene and beautiful oasis for the contemplation and enjoyment of art. We hope that the Nasher Sculpture Center will become a "must-see" attraction in the cultural life of Texas and the nation and that it will play an important role among museums worldwide in the presentation, study, appreciation, and conservation of modern sculpture while acting as a catalyst in the future development of downtown Dallas.

The building of the Nasher Sculpture Center is the culmination of decades of collecting and thinking about the important role that art can play in education and our daily lives. It is a unique institution, and I hope it gives you as much pleasure in your visitations as we have enjoyed in its creation.

Raymond Nasher
Founder

complemented by a relatively small gallery and services building. During the design period, however, it became clear that in order to do justice to the presentation of the many indoor works in the collection, more interior gallery space would be needed. From the start, I insisted that the facility be architecturally distinguished. Although we gave some thought to conducting a formal design competition, I decided that such an approach was unnecessarily cumbersome, especially since my involvement in real estate development and the art world over many years had given me a fair knowledge of the work of most of the internationally well-known architects.

I then started a round of informal conversations with a number of prominent architects and landscape designers, including my eventual choice, Renzo Piano. I had long admired Renzo's design for the Menil Collection and Twombly Gallery in Houston, the Beyeler Foundation in Basel, and the Centre Pompidou in Paris. More important, I became excited about his concept of a serene setting with an elegant stone and glass building and adjacent orchardlike garden in the midst of a noisy city environment. So in early 1997 Renzo and I, later in collaboration with Peter Walker, the noted landscape architect, started the exhilarating process of creating the Nasher Sculpture Center. The design we ultimately adopted was really the third concept that we studied. We looked first at placing the building along Harwood Street on the west side of our lot facing the DMA, then at a location at the northern end close to the DMA parking facility. But both had major drawbacks. Finally we decided that the optimal location was at the south end of the property with an entrance off Flora Street, the main axis of the Dallas Arts District.

We envisioned a building that would offer full museum amenities and services even if modestly scaled. The final design consists of two levels with total space of 55,000 square feet. The structure is simple but elegant in detail and rich in its combination of materials. The ground level has five long bays, defined by travertine marble walls with the bay ends constructed of clear glass, allowing a continuous visual connection between inside and out and a close interrelationship between art, architecture, and nature. The roof is also clear glass, vaulted and covered on the outside by a unique cast and painted aluminum sunscreen that allows only indirect north light into the galleries.

One of the end bays contains a bookstore, a conference room, and some of the Center's management offices. The other end bay houses a café with both indoor and outdoor seating on a terrace overlooking the garden and a pool with fountain.

Two of the interior bays are devoted exclusively to the exhibition of art from the Nasher collection and special exhibitions including work borrowed from other museums and collectors. Since the Nasher Sculpture Center building and garden are not large enough to hold all of the Nasher collection at any one time, art will periodically be rotated so that the installations are constantly refreshed.

persuaded by knowledgeable people in the art world that we truly did have a collection that represented a broad survey of important developments in modern and contemporary sculpture. A first exhibition of the collection at Southern Methodist University in 1978 was followed by a large-scale survey organized by Steven Nash and Nan Rosenthal in 1987–88 that appeared at the Dallas Museum of Art and the National Gallery of Art in Washington and then toured to the Centro de Arte Reina Sofia in Madrid, the Forte di Belvedere in Florence, and the Tel Aviv Museum of Art. Then, in 1996–97, the collection was exhibited at the Fine Arts Museums of San Francisco and the Solomon R. Guggenheim Museum in New York. The critical and popular success of the early tour confirmed for Patsy and me that our goal must be to keep our collection together and make it available to the public; in other words, to turn our private passion into a public treasure.

Our original hope was that we could eventually convert our house and its seven acres of wooded land into a private museum open to the public by appointment. On later reflection, however, I concluded that this approach, no matter how wonderful the setting, had several serious drawbacks. Most important, the residential character of the neighborhood would severely limit the number of visitors, especially schoolchildren, who could enjoy the collection.

Other alternatives were considered, including a merger of the collection into an existing museum, where it could remain separate and intact and contribute to the quality and character of that particular museum.

During the early 1990s I had numerous discussions with several important, large-city museums in the United States, including the Dallas Museum of Art, about such an arrangement. After much research and thoughtful consideration, however, my family and I decided that the inevitable and perfectly legitimate compromises that would have to be made to associate with a collaborating institution would dilute our ability to present our collection in keeping with our vision. So, we decided to forego the partial funding that the other institutions offered and fully finance a sculpture center through our family's Nasher Foundation. It also became clear that the Center should be built in Dallas, the city where Patsy and my children were born and grew up and where I had my good fortune.

The next step, the choice of a site in Dallas, was relatively easy since there was an existing 2.4-acre parking lot in the Dallas Arts District adjacent to the Dallas Museum of Art (DMA) that we were able to acquire, albeit not without some difficulty, in 1997. The site's advantages were several. Its proximity to the DMA would facilitate a close collaboration between the two institutions on exhibition, education, and other public programs. Even more advantageous, we thought, was that its true urban location would make the Center accessible to more people than would a suburban or a rural site.

While the extended negotiations for purchase of the property were going on, I began seriously considering the choice of an architect. My early concept for the Sculpture Center was for a large garden

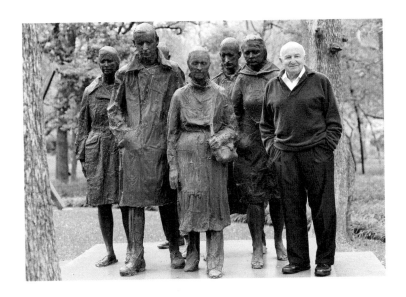

Raymond Nasher with George Segal's
Rush Hour (1983, cast 1985–86), spring 2000

Founder's Statement

The opening of the new Nasher Sculpture Center in downtown Dallas brings a sense of accomplishment and great civic pride to my family and me. It represents for us the realization of a longtime dream, and we hope that it fulfills the role of cultural excellence and leadership that we envision for the immediate community and far beyond.

The history of the Nasher Sculpture Center really starts with a trip to Mexico in 1950 by my late wife, Patsy, and me. It was there that we became interested in pre-Columbian art and started acquiring a collection of sculptures and artifacts that helped whet our appetites for modern sculpture and led eventually to our dedicated collecting in that field.

The joy that my wife and I derived from living every day with great art, and sharing this art with others, spurred the growth of our collection of modern sculpture in both quantity and breadth to the point where it now includes more than three hundred works in many different media and stylistic expressions. The collection is more fully described elsewhere in this book, but, briefly, it begins with Auguste Rodin and Paul Gauguin, takes on particular depth in its representation of Henri Matisse, Pablo Picasso, Alberto Giacometti, and other modern masters, and extends through such contemporary artists as Mark di Suvero, Magdalena Abakanowicz, Richard Serra, Joel Shapiro, and many others. We did not buy with the grand purpose of creating a "collection"; we simply bought art that we liked, that struck us emotionally and intellectually, and that seemed to us to achieve the highest levels of quality. It was not until the mid-1980s, a few years before Patsy's sad death in 1988, that we were

New York, Madrid, Florence, and Tel Aviv—or from the two major publications devoted to it—*A Century of Modern Sculpture: The Patsy and Raymond Nasher Collection* (Dallas Museum of Art and National Gallery of Art, 1987) and *A Century of Sculpture: The Nasher Collection* (Solomon R. Guggenheim Museum, 1996)—the new Nasher Sculpture Center offers an opportunity for renewed acquaintance in a setting specially designed as a showcase for sculpture. For those to whom the collection is unknown, a visit to the Center will, we think, provide an eye-opening and engrossing experience. All of the individuals mentioned above and others too numerous to acknowledge have helped bring this long-standing dream of Patsy and Raymond Nasher to fruition. We thank all of you.

Steven A. Nash
Director

he and his wife, Patsy, who sadly passed away in 1988, had begun even in the mid-1980s to think of ways they could make their growing collection available to the public. The opening of the Nasher Sculpture Center represents the fulfillment of this shared dream.

When it came to selecting an architect for the Center, Ray showed little hesitation in choosing Renzo Piano, who had already proved himself a master of museum design for smaller institutions that place highest priority on superb viewing conditions for art. It has been a great pleasure to work with Piano on this project and to follow step by step his sensitive solutions to all aspects of our program. Assisting him from the Renzo Piano Building Workshop were, most prominently among others, Emmanuela Baglietto, Brett Terpeluk, and Shunji Ishida. RPBW's representative in the United States for the project was Mark Wamble of Interloop A/D in Houston who, with his associates Ben Thorne and Dawn Finley, also provided architectural services for the construction of the site-specific work by James Turrell in our garden. Of course, the notion of a major sculpture garden was basic to the conception of the Center from the beginning, and for landscape design, we have been fortunate to enjoy the collaboration and creativity of Peter Walker of Peter Walker and Partners, and his able team consisting of Doug Findlay, Jennifer Brooke, Gisela Steber, and Tony Sinkowsky.

Assisting Raymond Nasher throughout the development of the Nasher Sculpture Center was his trusted colleague Elliot Cattarulla, Executive Director of the Nasher Foundation. Our Project Manager, Vel Hawes, has been absolutely crucial to the success of the project, and Andrea Nasher, one of Ray and Patsy's daughters and a member of the board of the Nasher Foundation, has also played a key role in planning from the outset. All staff members of the Center have assisted in myriad ways to help bring this new institution up to its full potential. I want especially to thank Dakin Hart, Assistant Director; Krista Farber, Director of Marketing and Development; Jed Morse, Assistant Curator; Jennifer Ritchie, Head of Registration and Information Services; Maria May, Marketing and Development Associate; Joanna Rowntree, Conservator; Pamela Franks, Curator of Scholarly and Public Programs; and Dean Perry, Facilities Manager. To our many colleagues at Beck Construction and Beck Architecture who brought professional expertise and diligence to all aspects of the construction process, we salute you.

For their design of this book and all of the identity graphics for the Nasher Sculpture Center, we are most grateful for the creative services of 2x4 in New York, including Michael Rock, Georgie Stout, Katie Andresen, and Alex Lin. Mark Thistlethwaite from the art history faculty at Texas Christian University provided a thorough essay tracing the development of the Center's building and garden, and Tim Hursley has documented the progress of the project from the very beginning through his superb photographs. Fronia W. Simpson very ably assisted with the editing of texts for the book.

For audiences who know the Nasher collection from its tours to cities in the United States and abroad—Dallas, Washington, D.C., San Francisco,

Preface

This book is published on the occasion of the opening of the Nasher Sculpture Center in the Dallas Arts District in October 2003. It provides information and visual documentation on the development of the Sculpture Center and the magnificent collection of modern and contemporary sculpture assembled by Raymond and Patsy Nasher for which the Center now becomes home. It is with considerable excitement and pride that all of us associated with the creation of this new institution open its doors to the public. Simultaneously we launch a program of installations, conservation, research, publications, exhibitions, and other educational events that will mark the Nasher Sculpture Center as a dynamic and innovative contributor to cultural developments both regionally and internationally. Its distinctive combination of elegant architecture, serene and welcoming sculpture park, outstanding collection, and urban setting makes it unusual among the world's museums and provides the basis for an ambitious mission to explore and bring to greater recognition the creative achievements of sculpture over the past 125 years.

We owe a great debt of thanks to the many people who have provided unstinting support and assistance in the making of both the Nasher Sculpture Center and this commemorative book.

Our founder, Raymond D. Nasher, conceived of the Center nearly ten years ago and since then has devoted his great vision, energy, high standards of quality, and single-handed financial support to making it a reality. As he notes in the Founder's Statement that follows this preface,

Contents